#PHOTO52

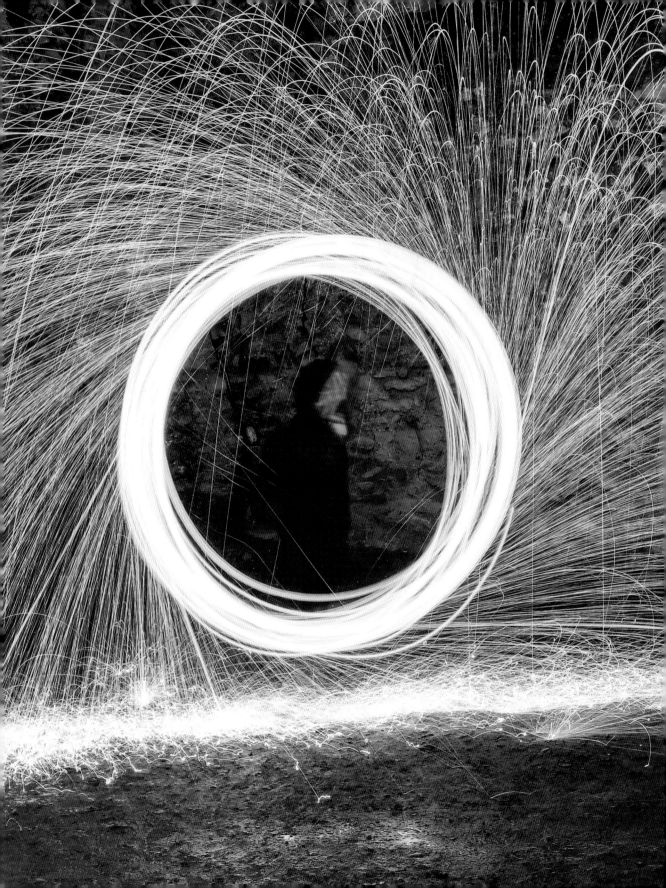

#PHOTO52

52 weekly projects to make
you a better photographer
Chris Gatcum

ilex

An Hachette UK Company
www.hachette.co.uk

First published in Great Britain in 2021 by
ILEX, an imprint of Octopus Publishing Group Ltd
Octopus Publishing Group
Carmelite House
50 Victoria Embankment
London, EC4Y 0DZ
www.octopusbooks.co.uk
www.octopusbooksusa.com

This material was previously published in *Creative
Digital Photography: 52 Weekend Projects*, *Creative
Digital Photography: 52 More Weekend Projects* and
The Weekend Photographer: 52 Creative Photo Projects.

Distributed in the US by Hachette Book Group
1290 Avenue of the Americas , 4th and 5th Floors
New York, NY 10104

Distributed in Canada by Canadian Manda Group
664 Annette St. Toronto, Ontario, Canada M6S 2C8

Publisher: Alison Starling
Commissioning Editor: Richard Collins
Managing Editor: Rachel Silverlight
Editorial Assistant: Ellen Sandford O'Neill
Art Director: Ben Gardiner
Design: JC Lanaway
Senior Production Manager: Peter Hunt

ISBN 978-1-78157-850-6

A CIP catalogue record for this book
is available from the British Library

10 9 8 7 6 5 4 3 2 1

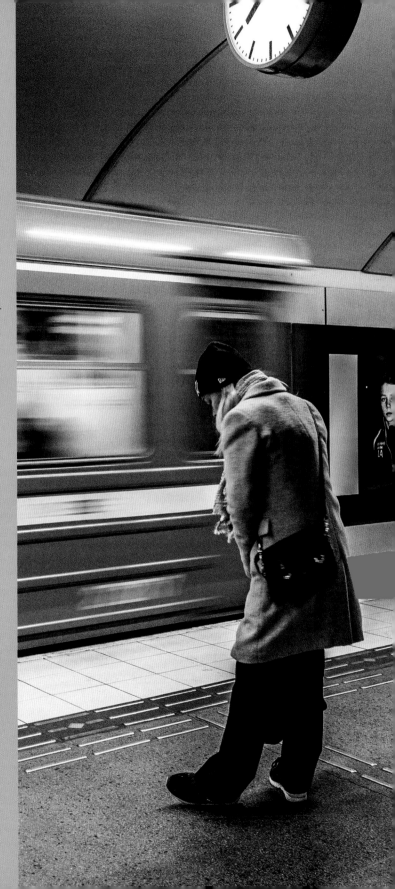

CONTENTS

INTRODUCTION

A photographer's journey is very similar to that of a child developing into an adult. As a child, everything is new and exciting: learning to walk, learning to talk, learning to ride a bike, learning to love—it's all huge fun, and as kids we throw ourselves fully into any fresh adventure that comes our way. But as we grow we start to lose that, and as youthful enthusiasm fades, routine can start to creep in where spontaneity once lived.

The same thing can happen on our photographic journey. When we start out there's a heck of a lot to get to grips with, and plenty of Eureka! moments to be enjoyed—learning and exploration and discovery are all naturally exciting parts of the process. But once the initial excitement of unboxing a new camera or phone wears off, and we've got to grips with aperture, shutter speed, ISO, focus, and all those other technicalities, there's less "new" to discover. At this point, the hardest part of photography is no longer the mechanics, it's maintaining motivation. Unless you're careful you can find yourself sliding slowly into a proverbial rut, taking the same pictures in the same places with the same settings. As in life, a safe routine can begin to creep in, and creativity can start to stagnate.

The good news is that it's not that difficult to get your photo mojo back. All you need to do is reconnect with your inner photographic child, effectively turning back the clock and getting playful with your camera again. Which is precisely where this book comes in.

Over the pages that follow you will find 52 projects that will help drag you out of any creative rut. Even if your photography hasn't stalled, you can still take these ideas and use them to try new things with your camera and keep the love alive. I like to think of it as a 12-month photographic rejuvenation plan, where you can pick a project a week to give your photography a boost. That's right, you've just bought a whole year of photographic inspiration!

But where to begin? Obviously, you could start at the start and work your way through from project 1 to 52 but, like your photography, this book doesn't have to walk a conventional path. A better approach (in my opinion) would be to choose your own adventure. You might alternate the chapters, perhaps shooting creatively one week, making (and using!) your own equipment or lighting accessory the next, and then heading to the digital darkroom the week after that. Or maybe you'll choose a weather-based approach? If it's going to be raining for the week, there are plenty of indoor studio projects to choose from, or you could opt for a session at the computer. Are you expecting clear night skies? Awesome—that's perfect for shooting star effects or experimenting with light painting. Overcast? Well, some ultra-long exposures might work well here.

To be honest, though, how you choose to use this book is up to you, not me—these are your projects now, and it's your call how you work through them. All I ask is that you have fun doing it!

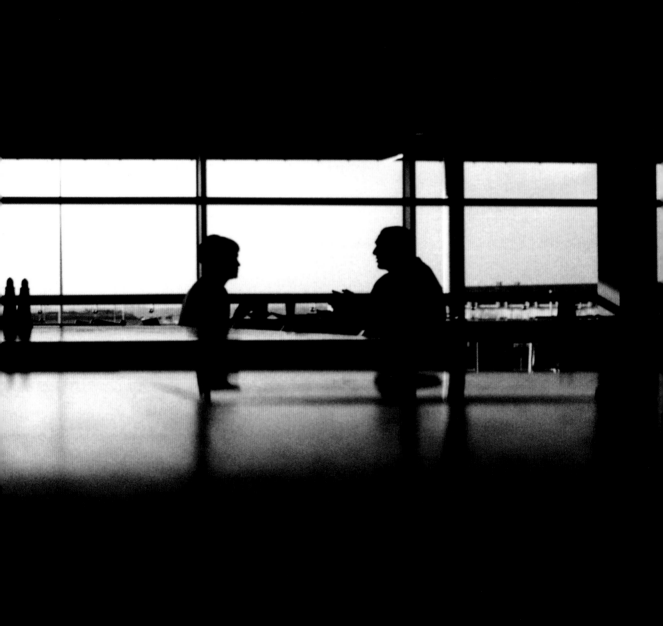

1

SHOOTING CREATIVELY

Putting the "creative" into your creative photography starts the moment you decide to take a picture. It doesn't matter whether it's a spontaneous snap or a considered still life; the creative process has begun. After that a whole host of options sit in front of you, although most photographers only consider three things—framing, exposure, and focus.

This chapter goes way beyond this basic trio of choices, covering a range of exciting projects and techniques that you might not have considered before. So whether you want to photograph smoke or water droplets, shoot the stars, or get inspired by blur, this is the place to start developing your creative camera skills.

#01 CROSS POLARIZING

If you've ever been driving while wearing polarized sunglasses you've probably seen strange patterns on car windshields. This is because car windows are made of tempered, heat-toughened glass for safety, and the tempering process puts the glass under internal stress, which in turn affects the way it reacts to light. The polarized glasses reveal areas of the window that were put under stress when it was manufactured, thanks to a phenomenon known as "birefringence." Other materials, such as transparent, injection-molded plastic, are also birefringent, which is why the plastic covers over the displays of MP3 players and wristwatches often show rainbow patterns when viewed through polarized glasses.

Photographers also use polarizing lenses (in the form of polarizing filters), to cut down the reflections from glass, and to reduce highlights on wet or moist objects. This is just like shooting through polarized sunglasses and, if you combine a polarized filter with a polarized light source, things start getting really interesting. This technique—known as "cross polarizing"—is important to science, where it is used in the study of crystals and microorganisms. But while scientists use it for its scientific potential, creative photographers can use it to produce stunning pictures where the normally invisible stress lines in plastic objects are transformed into beautiful, multicolored rainbows.

The traditional way of producing polarized light is to buy a sheet of polarizing plastic, or a polarizing gel, and tape it over a light source. This works well, but polarizing gels are expensive, and once they get scratched they become less efficient. However, the good news is you probably own a convenient source of polarized light already—the LCD screen used by a laptop or flat-panel TV or monitor—and there's no reason why you can't start exploiting this in your photography.

DIFFICULTY ★ ★

WHAT YOU NEED

- Digital SLR camera
- Polarizing filter
- Transparent plastic object, such as a ruler, protractor, or measuring cup
- LCD monitor or television
- Tripod

USEFUL TIPS

Generally, it's not a good idea to rest the object you're photographing directly on the LCD screen. Not only do you risk damaging the screen, but the screen itself could be in focus, revealing the grid pattern of the red, green, and blue pixels that make up the display.

If you position your screen horizontally you can position a sheet of glass above it to rest your subject on—the glass won't be affected by the polarization.

Use a macro lens or close-up lens to crop in close and create abstract shots of the kaleidoscopic colors.

Try converting your cross-polarized images into black and white and overlay them with a solid color for striking results, such as this picture of a recorder (right).

1 To set your polarized light source, turn your screen's brightness to full, and fill the screen with a white image. This is most easily done with a computer as you can just open a blank window and extend it to fill the monitor.

2 Put the polarizing filter on your camera lens, and mount the camera on a tripod in front of the screen.

3 Rotate the polarizing filter on your lens until the image through the viewfinder is black, or as dark as possible. Rotating the filter gives you different degrees of polarization, so experiment with the angle. You'll likely find that you'll create the most striking photos when the effect is as dark as possible.

4 Place your transparent plastic object between the LCD screen and the camera, and frame and focus your shot—you should see the colored effect through your camera's viewfinder or on the rear LCD screen.

5 Turn off, or cover, any other light sources and take your shot. As LCD displays don't produce that much light and the polarizing filter consumes up to two-stops worth of light, your exposure will be fairly long (which is why you should use a tripod). Using a remote release is also a good idea, but if you don't have one you can use your camera's self-timer instead—either way, you want to try and avoid any camera shake during your long exposures.

6 Once you've taken your shot, review the image on your camera's LCD screen. Adjust the exposure if you need to, using the EV (Exposure Value) setting to make your image lighter or darker. Then experiment like crazy! Different objects will produce different results.

#02 STUNNING SILHOUETTES

Silhouettes were a popular form of image-making, long before photography had been conceived. However, they have always received something of a mixed reception in photography: a silhouette that's done badly can end up as an unreadable mess of black, while attempting to photograph a subject against a bright background can easily lead to accidental silhouettes as your camera attempts to produce the "best" exposure.

Yet while the humble silhouette is maligned by some photographers, there's no doubt that the stark black outlines also have a graphic power where shape becomes more important than detail, and a story can be told using broader strokes. So, why not set your preconceptions aside and think about adding stunning silhouettes to your creative repertoire?

SUBJECTS

The easiest way to create a poor silhouette is to pick an inappropriate subject: Something that appears to have great potential when you look at it may not be quite so hot when you photograph it. As a general rule, the simpler the shapes, the fewer there are, and the less they overlap, the stronger the result will be. For example, if you're photographing a couple of figures in silhouette, make sure there is space around each of them so they can both be seen in their entirety. You may know it's two people when you photograph them, but if they overlap it's easy for them to be transformed into a two-headed, four-armed freak when they're seen in silhouette (although that could work!).

This isn't helped by the fact that objects seen in silhouette tend to lose a certain amount of depth. This means that you also need to be aware of what is behind and in front of your subject, as something in the foreground will not necessarily be read as being closer when it's photographed—it could instead just appear oversized.

WHAT YOU NEED

- All you need is a camera!

USEFUL TIPS

Although your choice of subject is important, you should also pay attention to the background in your shot. Positioning your subject against a relatively plain background will enhance the graphic nature of your silhouettes. A classic background is a fiery sky at sunset, although you may find that you need to shoot from a low viewpoint to make best use of the strong colors that occur.

If your potential subject is close to the camera, make sure the built-in flash is switched off before attempting to shoot a silhouette: if the flash fires, you won't get a silhouette.

Consider setting the "wrong" white balance deliberately: Using a tungsten white balance setting in daylight will give your silhouette shot a strong blue color cast, similar to using a blue filter on the lens or toning a monochrome picture.

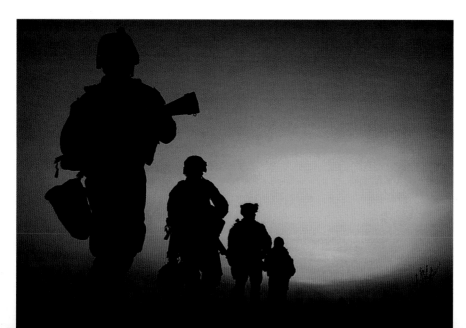

LEFT The outlines of the figures toward the center of this shot overlap slightly, but the larger figure at the left provides us with a point of reference—in this case, US marines on patrol.

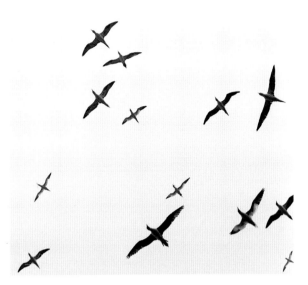

ABOVE If you aim your camera at a featureless sky, it's almost guaranteed to underexpose the shot. Here it transforms the birds into dark silhouettes.

RIGHT I treated this silhouette to a redscale look during post-production: Project 48 explains how it was done.

EXPOSURE

The most striking silhouettes utilize strong backlighting and a carefully placed exposure so the subject is rendered without detail. However, some cameras actively attempt to identify and overcome strong backlighting when you use their general metering mode (matrix metering, evaluative metering, or similar), either by adjusting the exposure to compensate, or by employing some form of dynamic range optimization. This doesn't mean that your camera's meter is useless for shooting silhouettes—you simply need to know what it will do.

If you find it consistently tries to compensate for heavy backlighting, then one option is to dial in negative (-) exposure compensation. This will effectively underexpose the shot, reducing the brightness of your subject and helping to transform it into a strong, featureless shadow.

Alternatively, you can use your camera's spot meter. Take an exposure reading from an area you want to appear as a midtone (usually a bright area in the background) and either lock the exposure with your camera's Automatic Exposure Lock (AEL) feature, or set the shooting mode to Manual (M) and dial in the aperture and shutter speed yourself. In both instances you will have an exposure that is set for the (bright) background, with the unlit subject falling into shadow.

POST-PROCESSING

Providing you get your exposure right in-camera, there's often minimal need for any post-capture image editing. However, that's not to say that your silhouettes won't benefit from a touch of post-production work. For a start, you may want to make sure that your subject is a pure black silhouette by "burning in" the dark tones using your editing program's "Burn" tool (or similar).

The background may also benefit from being darkened slightly, which will help intensify the color. This is especially effective with sunset silhouettes, where an overall reduction in brightness (using Levels, for example) can really make the colors "pop." This can be taken further by combining it with a slight increase in color saturation or vibrance as well—most editing programs have at least one tool that can be used to intensify the colors in an image.

Alternatively, you may find that you want to remove the color altogether to create a black-and-white image. With certain shots this can be incredibly effective, and imbue your image with a mysterious, film noir look. Toning your silhouettes can also work well, be it a fairly traditional sepia tone, a more extreme redscale look (see Project 48), or something else altogether.

#03 DIFFRACTION STAR EFFECTS

In the 1970s and '80s it was very popular for photographers shooting at night to use star or "cross" filters, which are simply clear glass filters with a fine, regular grid engraved into one surface. When these filters are used to photograph bright, point-sources of light—such as streetlamps at night—they create the effect of starbursts. However, star filters are not subtle, and the engraved lines also cause another optical effect known as dispersion, which results in a rainbow effect in the streaks of light.

It's not too surprising that the overbearing look of star filters has led them to fall out of favor in recent years, and I won't claim for a minute that everyone should rush out and take all their pictures with one. At the same time, it's one of those effects that can actually work in some instances, and just because it's not currently fashionable doesn't mean you can't do it anymore! Best of all, your camera's probably already got a built-in star filter—I bet it doesn't tell you *that* in the manual!

This project takes advantage of a regularly occurring optical phenomenon known as "diffraction," which is something most, if not all, lenses suffer from. Diffraction is the slight bending of light around small openings (the aperture in your camera in this instance), and it's usually thought of as a problem since it's the primary cause of loss of sharpness when a lens is set to a small aperture. But what one person sees as a problem, we can see as a solution, because it is diffraction that will be creating our starbursts.

This project works best if you can find yourself a night or low-light scene with a few point-sources of light; streetlamps and Christmas lights work well, while light sources that have larger surface areas, such as shop signs or fluorescent tubes, do not. Take a walk around a town or city at dusk, or at night, and you will be sure to find somewhere suitable.

Once you find a scene you want to shoot, set your camera up on a tripod and switch to Aperture Priority mode. Set a small aperture and start taking some shots. If you're using an SLR, a lens set to *f*/4 will not have very pronounced starbursts, so set your aperture to *f*/16, or smaller. This should produce very clear starbursts, which you can check on your camera's LCD screen. And that's all there is to it—just by setting a small aperture you've discovered the "starburst filter" mode you didn't know your camera had.

DIFFICULTY ★

WHAT YOU NEED

- Point-and-shoot or digital SLR camera with adjustable aperture
- Tripod

USEFUL TIPS

The number of rays from each starburst is related to the number of aperture blades in your lens, so as well as experimenting with the aperture to see what effect it has, it's worth experimenting with different lenses as well. Each lens you use will produce slightly different starbursts.

ABOVE RIGHT Simply setting a small aperture and photographing point-sources of light will produce fantastic starbursts. The number of aperture blades and the aperture setting you use will determine the number—and intensity—of the "bursts." The image above left (and detail, above right) was taken with the aperture set at *f*/16.

RIGHT A "proper" 4-point starburst filter was used for this image. The effect is more pronounced, but why buy a filter when you can change your aperture for free?

LEFT Combined with a beautiful contrast in light and color, starbursts add magic to a gleaming river scene.

#04 SOFT FOCUS

DIFFICULTY ★

WHAT YOU NEED

- Point-and-shoot or digital SLR camera
- Nylon stockings and rubber band

OR

- Petroleum jelly and UV/skylight filter

USEFUL TIPS

When using nylons, the more you stretch the fabric the less intense the softening effect becomes.

You can also control the soft focus effect with the thickness of the material you put over the lens—use thicker nylons, or two pieces to increase the softness.

The aperture you use when you shoot through nylons will affect the focus. Smaller lens apertures increase the depth of field, so your disruptive material will be slightly more in focus. While you might not see much difference through the lens, the overall soft focus effect will be greater.

Like starburst filters, taking soft focus pictures was once so popular it seemed like it was impossible to find images that didn't have a diffuse look. However, while the soft-focus effect has definitely fallen from grace (for good reason, some might say), this doesn't mean it can't have a place in the creative photographer's armory. It might seem strange to spend good money buying the sharpest lens you can afford and then produce "soft" pictures, but not all photographs call for absolute clarity.

Sometimes we don't want to show all the detail—in a portrait where winkles and skin blemishes need to be hidden, for example—while at other times a soft-focus effect can be used to emphasize the atmosphere in a landscape or a still life, letting us create mist where there is none, or simply blurring the detail so we are left with suggestive outlines and shapes. At the extreme, soft focus can create surreal effects, smearing colors and tones across the frame.

Creating soft focus is extremely easy, and even with the most basic materials you can quickly produce a wide range of blur and color effects. The simplest method is to simply breathe on the front of your lens so it steams up. As the mist clears you can shoot through it, timing the shot to the amount of mist still left on the lens. You have to be quick as the mist can clear suddenly, and it doesn't always clear evenly—especially if you are outside in a breeze— which makes it really unpredictable, but, hey, it's completely free, what do you expect?

PETROLEUM JELLY

Slightly more predictable than breathing on your lens, but a little more messy, this classic soft-focus method is quick, easy, and extremely flexible. It involves smearing a thin film of petroleum jelly on the surface of a clear filter, such as a UV or skylight filter. The effect is entirely dependent on how much jelly you apply and how you apply it. Use a tiny amount and smear it evenly to create a subtle softening of the image, or use a bit more and spread it in streaks across the glass to break your image into a dreamlike mass of color and tone. You can even apply the jelly selectively, leaving the center of the glass clear so only the edges are softened.

The great thing about this technique is the control you have over the final image. You can apply patterns or dabs for different effects, and if it doesn't work you can just wipe the filter clean and start again. The only thing you need to take care with is that you use a filter, and never apply jelly to the front element of your lens. While the jelly can be cleaned off a filter very easily with a lens tissue or soap and water, it can permanently damage your lens coatings if you apply it directly.

NYLONS

A favorite with fashion photographers (possibly because they have a lot of nylons lying around), stretching nylons across the lens opens up a whole world of opportunity as they not only reduce the sharpness, but, depending on the color you use, can also change the color of the image. Using black material tends to smudge the shadows in a picture more than it affects the highlights, while white stockings have the opposite effect. Brown material adds warmth to an image as well as softening it, making it a great option for portraits.

Once you've got yourself an old stocking or pair of nylons, cut out a small section of material roughly 5 inches (12.5cm) square. Stretch the material over the front element of the lens making sure it is flat, even, and well-stretched. Secure it with a rubber band to hold it in place on the barrel of the lens, taking care to position the rubber band to hold the nylon in place around the autofocus ring so the lens can still focus.

#05 BRENIZER METHOD

Bigger isn't necessarily better, but there are certain benefits to using a digital camera with a large sensor. Aside from reduced noise levels, one of those benefits is that you can shoot images with a very shallow depth of field using a relatively wide-angle lens set to maximum aperture.

Professional fashion and wedding photographers commonly use full-frame, or even medium-format cameras so they can achieve this distinctive visual style, but it is much harder to recreate this look with a cropped-sensor camera. Often, the only way to achieve an appreciably shallow depth of field on a smaller format camera is to use a telephoto lens, but this limits your angle of view, making it difficult to frame a shot so that a generous amount of background is included.

So what do you do if you want a wide-angle view and a shallow depth of field? Well, according to the laws of physics this simply isn't possible—the two are mutually exclusive. However, thanks to the magic of image-editing software this is no longer strictly true, and there is a way to replicate this look with a standard digital SLR. The method described is largely credited to photographer Ryan Brenizer (www.ryanbrenizer.com), and for this reason is often referred to as the "Brenizer Method." The technique involves shooting multiple images and stitching them together using Adobe Photoshop's Photomerge function: a similar process to stitching together a panoramic photograph, but with a very different end result in mind.

WHAT YOU NEED

- Telephoto lens with wide aperture (*f*/2.8–*f*/4)
- Image-editing program with Photomerge/stitching function (e.g. Photoshop)
- Tripod

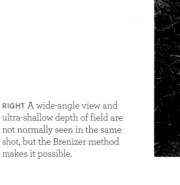

RIGHT A wide-angle view and ultra-shallow depth of field are not normally seen in the same shot, but the Brenizer method makes it possible.

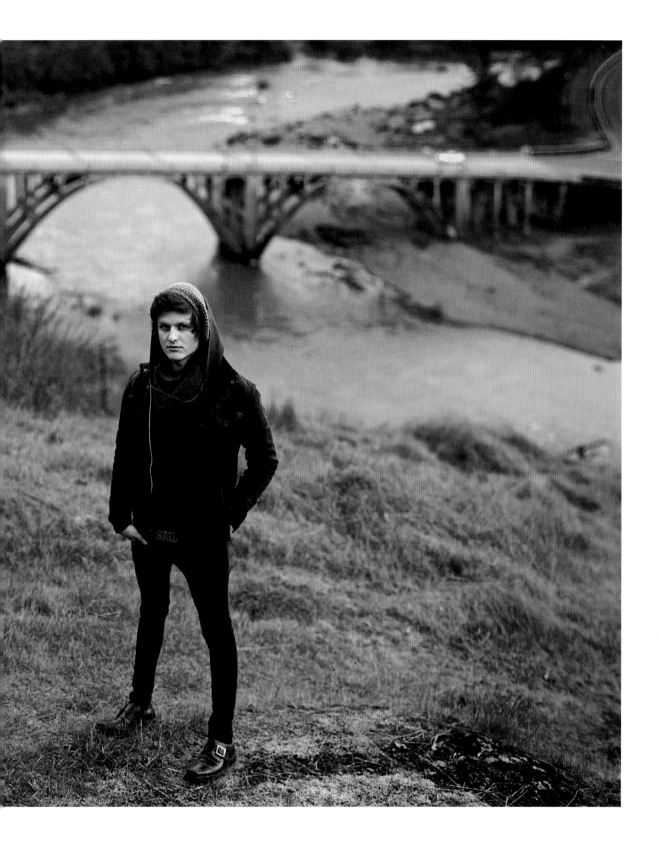

#05

USEFUL TIPS

If your subject is a person, ask them to hold their position as best they can until you've stopped shooting.

Don't rush the shooting stage: the final image is only as good as all the individual images you've shot.

The more even the lighting of the scene, the easier it will be to set the correct exposure for the images—this method makes ND graduated filters challenging to use.

Shoot a greater area than the one you visualized for your final image: it is better to crop than to discover you haven't covered the entire scene.

LEFT Piecing your photograph together will look something like this.

SHOOTING

To achieve a shallow depth of field you will need to fit a reasonably long lens onto your camera: a focal length in the range of 85–105mm is a good starting point. If you're shooting with a compact camera use the longest end of the zoom range without using "digital" zoom. Set your camera to Manual to guarantee consistency across the range of images, and set the aperture to the maximum for the lens you're using. An aperture of f/2.8 is ideal, although it's also possible to get interesting results with an aperture of f/4 or f/5.6 with longer focal lengths. Set the shutter speed so you get an exposure that is correct for the scene you're shooting.

You can shoot either JPEG or Raw files, depending on your personal preference, and as always there are advantages and disadvantages to both. Shooting Raw files will certainly give you more control over the appearance of the final image sequence, but there will be a lot of images to process and they'll quickly fill a memory card. Conversely, if you shoot JPEGs it will be far less time-consuming, although the images may not be so easily optimized.

Composing your shot requires a certain amount of imagination, as you're going to shoot small sections of the scene to stitch together. As these individual segments will create the final image it's important to get it right, so try to visualize the edges of your final image and position yourself so that you can comfortably sweep your camera around to cover this entire area. Using a tripod is essential here.

Because the aim is to have just one distinct sliver of the scene looking sharp, you need to focus manually. Start by focusing on the main area you want sharp and then move the camera so that your first shot will be the top left corner of your scene. Take the shot and then pan right so that you overlap the first image slightly and shoot the next frame. Repeat this process until you reach the top right corner. Then, tilt the camera downward slightly and shoot again, this time panning from right to left until you reach the left edge of the image. Repeat this left-to-right, right-to-left shooting and panning until you've covered the entire area of your visualized final image. Then it's time to piece your photograph together.

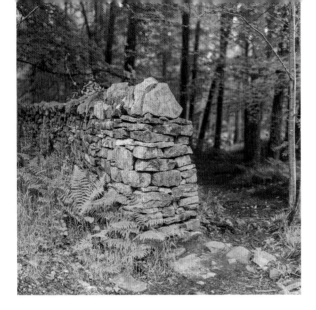

LEFT The Brenizer method can create a heightened sense of three dimensions in an otherwise two-dimensional photograph.

IMAGE BLENDING

1 Start by copying your sequence of images into a single folder on your computer.

2 Launch Photoshop and go to *File>Automate>Photomerge*.

3 Click Browse and navigate to your folder of images. Select them all by clicking on a file and then pressing Ctrl+A (Windows) or Cmd+A (Mac). Press Open to return to the main Photomerge dialog and then OK to begin the merging process.

4 Your images will be merged and the results opened as a new image, with the individual images on separate layers. You can flatten the layers by selecting *Layers>Flatten Image*, or merge them to a single floating layer by choosing *Layers>Merge Visible*.

5 Your image will look ragged and uneven at this point, so use the Crop tool to crop the image. You can also rotate the image if you need to, or correct for perspective distortion by checking the Perspective button on the toolbar and dragging the corners of the Crop frame.

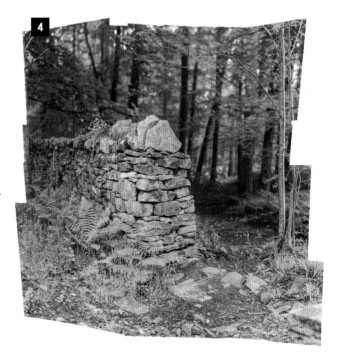

#06 CREATIVE BOKEH

Taken from the japanese word for "blurry" or "fuzzy," the term *bokeh* is used to describe the out of focus areas that usually occur in the background of an image. It is most noticeable in images taken with wide apertures—*f*/2.8 or wider—as the shallow depth of field throws backgrounds out of focus. If you look carefully at an image with a very small depth of field you might notice small, blurry geometric shapes in the background. This is bokeh.

The bokeh will take on the shape of the aperture blades of the lens that is being used, so it might appear as pentagons, hexagons, or octagons depending on the lens; if you use a catadioptric, or "mirror" lens, you'll get donut-shaped bokeh due the circular design of the mirror in the lens. For some photographers, having the "best" bokeh is a key concern, so much so that some lenses—particularly those designed for portrait photography—have near-circular aperture blades. However, for this project, we're not interested in the finest bokeh—we want to create our own personal bokeh shapes, so we can add a unique touch to our images.

WHAT YOU NEED

- Digital SLR camera
- Wide aperture lens (*f*/2.8 or wider)
- Black cardstock
- Scissors
- Craft knife
- Pencil
- Clear tape
- Compass

USEFUL TIPS

Set your lens to its widest setting to get the strongest effect from your bokeh filter.

Shooting close-up images will decrease your depth of field. Combine this with a wide aperture to maximize the bokeh effect in your pictures.

LEFT Small, maneuverable light sources, such as Christmas tree lights, are perfect for arranging in the background to create bokeh. Attaching them to wires allows them to be positioned and securely held in place, helping to create images like this one.

ABOVE LEFT & ABOVE RIGHT While pentagon-shaped bokeh is an interesting phenomena, it is not very engaging when captured in isolation. Try combining foreground detail with background bokeh to create images that are far more interesting.

MAKING A BOKEH FILTER

A bokeh filter is easy to make—it's nothing more than a circle of cardstock with your chosen bokeh shape cut out of it.

For the best results, choose a lens with an aperture of $f/1.8$ and make a note of the filter diameter (this is normally written on the lens). Using a compass, draw a circle the same diameter as your lens's filter thread on a piece of black cardstock.

Cut out the circle and draw your bokeh shape in the center of the card—solid shapes such as hearts and stars work well.

Finally, cut the shape out of the card disc with a craft knife and you've made your own bokeh filter. Simply push the filter carefully on to the filter thread on the front of your lens and you're ready to start shooting! A fold of tape on the edge of the filter will help you remove it from the lens.

#07 ZOOM BURST

Once you've learned how to take a zoom-burst shot you will never be stuck for a way to bring dynamism and life into your creative photos. Better still, this is not a technique that requires any complicated set-ups or lengthy image-editing—and you can achieve it with the standard zoom lens that comes with virtually any SLR, so it doesn't cost a thing.

To create a zoom-burst image you simply need to turn the zoom barrel on your lens while the shutter is open, either zooming in or out. The striking effect is created by the movement of the image on the sensor in a similar manner to motion blur and, in essence, that's all there is to it. Zoom-bursts are a great way of highlighting a subject in a much more dramatic manner than simply using a shallow depth of field, or to exaggerate the impression of speed in your sports photography. It can also produce stunning abstract images that are perfect for creating giant wall-art prints (see Project 51). Here are some pointers for getting great-looking zoom-bursts, even if you've never tried it before.

WHAT YOU NEED
- Digital SLR camera with zoom lens
- Tripod

USEFUL TIPS

The length of your exposure and the speed you zoom at will both affect the result, so experiment with the shutter duration.

Fire your camera's flash during the exposure to record a moment of sharpness during the zoom-burst.

LEFT, ABOVE & ABOVE RIGHT
Zoom-bursts can be used to enhance an action shot (left) or to simply create abstract images (above and above right).

1 Set the slowest ISO setting your camera has (usually ISO 100) and use your camera in Shutter Priority mode to set a shutter speed long enough to give you time to zoom. This can be anything from $1/50$ sec (which doesn't give you long) to a second or more. Line up your shot and begin turning the zoom smoothly as you trigger the shutter. Be sure that you have enough movement left in the zoom so the shutter closes before you reach the other end of the zoom range. This will keep the zoom effect even.

2 For most subjects, keep the camera as still as you can, preferably using a tripod. Any horizontal or vertical camera shake will be reflected in the zoom, which won't appear as a uniform pattern.

3 You'll find it easier to work in lower light situations, since these naturally require a longer shutter speed. In bright light you might need to use a neutral density filter to extend the exposure time.

4 Great creative subjects include pin-points of light, like a night-time cityscape. In these high-contrast situations you can try hand-holding the camera to combine the zoom-burst with deliberate camera shake for abstract results.

5 In general, you'll get the best results by turning the zoom barrel at a consistent speed. However, if you'd like to see the subject a little more sharply at one scale, stop turning the barrel before the end of the exposure, or begin the zoom half way into the exposure. This is great for creating the effect of light streaming through a stained-glass window, for example.

6 Zoom out as well as in, especially with a moving subject. If you zoom in on an approaching automobile, for example, it will seem to disappear, whereas zooming out so that it remains roughly the same size in the viewfinder will make it leap from a blurred background. Just make sure it's not coming right for you!

#08 FREELENSING

As the name suggests, freelensing involves "freeing" the lens from the camera body, resulting in photos that are characterized by a vintage feel that includes light leaks and a vignette. The depth of field is also shallow, no matter how far your subject is from your camera. However, the main reason to "freelens" is the control you have over the focus; you can move the focus point in all directions—forward or backward, up or down, and left or right—just by moving the detached lens. Because you are able to bring the focus point very close to the camera, freelensing is ideal for macro shots, but the tightened depth of field also allows you to apply a tilt/shift effect to your shots, where the scene seems miniaturized. The shallow depth of field can be utilized effectively in portraiture as well.

DIFFICULTY ★ ★

WHAT YOU NEED

- Camera with detachable lens
- Lens with wide aperture and 50mm+ focal length
- Tripod (optional)

LIGHT LEAK TIPS

With your lens detached, ambient light can easily get into the camera. These light leaks are one of the characteristics of a freelens image and indoors—or on a cloudy day outside—they can enhance the vintage feel of your shots. However, on a sunny day these leaks can be so intense that they become problematic, in which case you can cover up the gap with your hand or try to reduce the effect in your image-editing program.

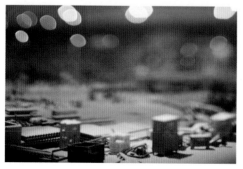

ABOVE LEFT & LEFT Tilting the lens as you hold it in front of your camera will introduce a tilt/shift look that's ideal for creating "miniature worlds."

WARNING

Whether you are looking through the viewfinder or using your camera's Live View mode to take freelensing photos, the film or sensor is directly exposed to the outside environment: the further the lens is from the camera body, the more likely dust is going to get into your camera. If you are not comfortable with this, then freelensing may not be the project for you.

LENS CHOICE

The lens is what matters most in freelensing. You will need a lens with a minimum focal length of 50mm (wider angle lenses will not work as effectively) and a large maximum aperture. You will also need to use a lens that has a manual aperture ring rather than relying on an electronic contact, otherwise you will find that you can only shoot at maximum aperture. A prime lens is also preferable to a zoom, but it's worth noting that as you aren't attaching the lens to your camera, it doesn't need to be the "correct" fitting—you don't need to use a Nikon F-mount lens on your Nikon camera, for example. With all of this in mind a manual focus, 50mm f/1.8 lens is ideal, and there are countless options that are readily available at a low cost on eBay.

GETTING STARTED

To start freelensing, set your camera to Manual and make sure that the shutter will fire without a lens attached; you may need to enable this in the camera's menu. If it isn't already removed, detach the lens and hold it close to the camera body, leaving a small gap between the camera and lens (a gap of a few millimeters will suffice). Adjust the position of the focus by moving the lens in front of the camera, as outlined on the following page, either looking through the viewfinder or using live view to guide you.

The aperture affects the depth of field and exposure as it usually does, but a good rule of thumb is to always start at the widest aperture setting, just so you can get a sense of the shallowest depth of field available with your lens (the widest aperture allows the greatest amount of light through the lens, so you don't necessarily have to worry about using a slow shutter speed). If you want a larger depth of field, adjust the aperture accordingly—the exposure can then be set using the shutter speed and ISO.

FOCUS

The most important (and the most difficult) element in freelensing is setting the focus. It is a good idea to start with infinity focus, and then to adjust the position of the focus from there, either by turning the focus ring or moving the lens. When the subject is close to you, the focus can be adjusted using either method, but when the subject is far away focusing only works when it is set to infinity. If you set the focus below infinity it will result in a totally out-of-focus image, so the only way to adjust focus in this case is by moving your lens. Tilting the lens—even slightly—will shift the focal point and change the whole composition of an image, so you can find yourself juggling the focus and composition to determine the point at which both elements are balanced.

Even if you focus carefully, do not expect your shots to turn out as sharply as they do when the lens is attached to the camera. Freelensing distorts how light is focused onto the film or sensor, and this compromises sharpness. Sharpness is most affected when the subject is far from the camera. A related issue is motion blur, and this is especially common in low-light shooting. Because you are holding the lens off from the camera, the smallest movement can be recorded by a long exposure, and even a tripod may not help: it will reduce any camera shake, but not any lens shake.

Aside from focus fall off, you will also likely notice a dark edge (vignette) on the side of the photo where the lens is furthest from the camera. These dark edges might be a problem when the subject you're trying to focus on is very far away and you want to tilt the lens: the further you tilt the lens, the larger the dark edges become. This is when post-processing comes in handy.

POST-PROCESSING

First, let's deal with excessive light leaks. These can usually be reduced by increasing the contrast of the photo, and it's fair to say that many freelensing photos require a contrast boost, especially as this can also make the image appear sharper. Dark edges can also be dealt with in a straightforward fashion. If the darkening is slight, it can be treated as a vignette, with your image-editing program's vignette removal/reduction tools usually proving sufficient to counter the edge shading. However, when the dark edges are taking away too much of the image, or are too dark for your vignetting correction tools, cropping may be the only answer.

#09 LIGHTBOX SHOTS

When photographers didn't have any choice but to shoot on film, a lightbox was an intrinsic part of any studio, allowing transparencies and negatives to be viewed and assessed, and decisions to be made over which was the "best" frame. With digital photography this is no longer necessary: images can be reviewed instantly on the camera's LCD screen, or on a computer monitor instead.

However, while a lightbox is of no use when it comes to reviewing digital images, it can certainly be useful in creating those images in the first place. For example, stand a lightbox on its side and you've instantly got a flat, diffuse light source: a less bulky, and often more convenient alternative to a softbox if you're shooting small-scale subjects. Alternatively, lie a lightbox flat and you can place items on top of it to create a "quick and dirty" white background that, in most instances, just needs the addition of a few strategically-placed reflectors to light your entire subject. Or you could stand a lightbox behind your subject to act as a background—and not just white, either. Add a lighting gel and you can introduce a uniformly lit, single-color background without having to use any additional lights.

DIFFICULTY ★

WHAT YOU NEED
- Camera
- Lightbox or light table (see Project 34)

X-RAY EFFECT

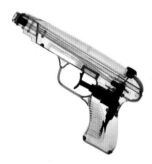

This black-and-white shot of a translucent plastic water pistol was originally photographed on a lightbox with a plain white background (above).

It was quickly transformed into a pseudo X-Ray using Photoshop. Inverting the image (*Image>Adjustments>Invert*) turned the gun white and the background black, with a subtle blue color-tint introduced using Variations (*Image>Adjustments>Variations*).

Printing the image onto acetate would enhance the physical feel of an X-Ray, which could then be mounted and displayed on a custom-made lightbox or light table (see Project 34).

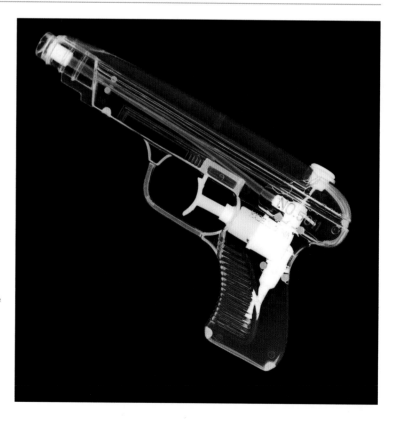

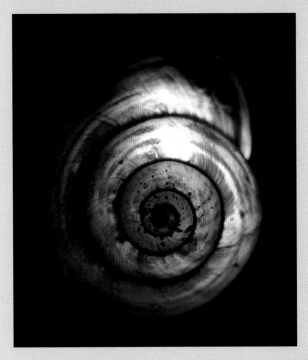

TRANSLUCENT OBJECTS

Objects that are naturally translucent can make great subjects for lightbox shots, with the backlighting revealing them in an entirely new way. The key to successful shots—as with most subjects—is getting the exposure right. In this instance it often means switching to your camera's spot meter option so that you can take a meter reading that isn't affected by the bright white background. Although this will prevent your camera from underexposing the subject heavily, you may find that you also need to use exposure compensation: +1EV is a good, general start point.

If your camera doesn't have a spot meter mode, use its center weighted option instead (or multiarea metering) and dial in a greater amount of positive (+) exposure compensation to lighten the image.

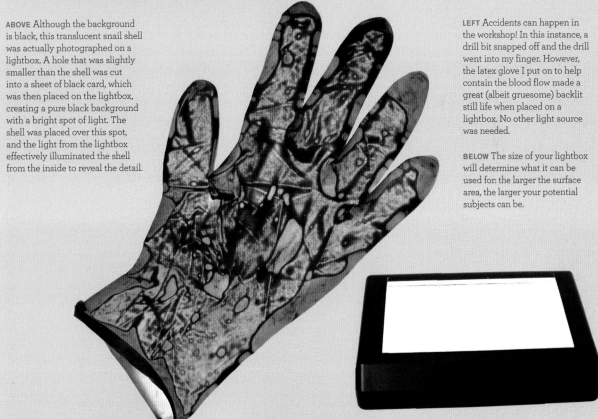

ABOVE Although the background is black, this translucent snail shell was actually photographed on a lightbox. A hole that was slightly smaller than the shell was cut into a sheet of black card, which was then placed on the lightbox, creating a pure black background with a bright spot of light. The shell was placed over this spot, and the light from the lightbox effectively illuminated the shell from the inside to reveal the detail.

LEFT Accidents can happen in the workshop! In this instance, a drill bit snapped off and the drill went into my finger. However, the latex glove I put on to help contain the blood flow made a great (albeit gruesome) backlit still life when placed on a lightbox. No other light source was needed.

BELOW The size of your lightbox will determine what it can be used for: the larger the surface area, the larger your potential subjects can be.

#09

COLORED BACKGROUNDS

Photographing your subject against a brightly colored background is a great way of making it leap from the page and look less like a traditional packshot or "cut-out" style catalog shot. The easiest way to achieve this is with a colored lighting gel: these are available from photographic and theatrical stores, as well as online. Lighting gels come in myriad colors, and it's simply a case of picking the one that works best for your image and placing it over the lightbox: position your colored background behind your subject; place your subject above it (on a sheet of glass, for example); or put your chosen object directly on it.

If you're using additional lighting, take care that the lights you use on your subject don't fall on the lightbox and create potentially distracting highlights (gels are highly reflective). On the plus side, you may also find that because the background is illuminated, it naturally "absorbs" any shadows cast by the subject, which can work in your favor.

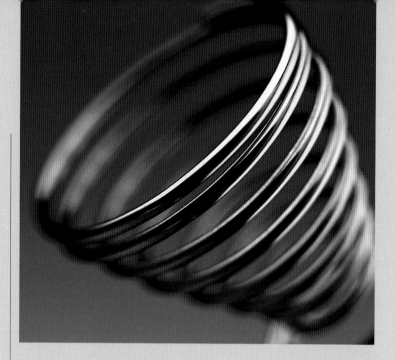

The intensity of the background color can be controlled through the exposure, and the color will be intensified by underexposing it slightly. However, as you can't do this by controlling the power of the lightbox, you will need to do it by controlling the ratio of your main light(s) to the background. Setting your main light so it is ½–1 stop brighter than the lightbox (and setting the exposure for your main light) will produce the strongly saturated background colors seen here.

ABOVE A gelled lightbox placed behind the subject will create a uniform background color in a very straightforward manner. However, tilting the lightbox, even slightly, can create a subtle graduated background instead: the brightness will decrease as the distance from the camera increases.

RIGHT These clockwork teeth were placed on a sheet of glass approximately 12 inches (30cm) above a green-gelled lightbox. The main light was ½-stop brighter than the background, which helped intensify the color.

INVERTING

The toy snail that became the subject of this photograph was found lying in the gutter, dirty and worn. Although it was once a deeply-saturated pink color, the elements had faded it heavily, and, as found, it wasn't the vibrant subject I wanted. However, inverting the original photograph transformed it into a deep, rich, blue-ish color. Rather than cheat and drop the background in at a later stage, a mid-green gel was used on the lightbox. When the colors were inverted (using *Image> Adjustments>Invert* in Photoshop), this became a strong magenta.

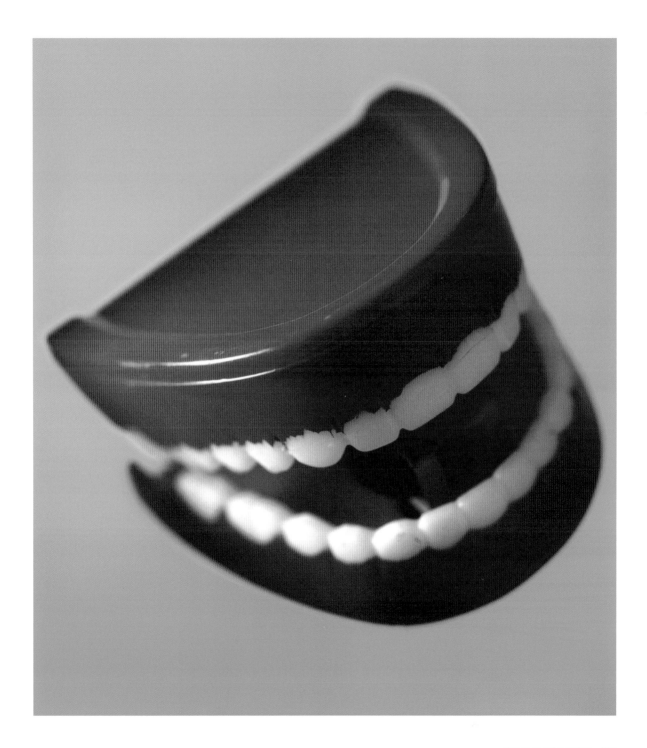

#10 CAMERA TOSSING

One of the latest extreme sports in photography is camera tossing, and it's definitely not something for the faint-hearted! At its most basic, camera tossing involves two steps: triggering the camera and tossing it into the air. That's really all there is to it, but the results can be fascinating, abstract forms of light art, where every image is unique, and nothing can be replicated. However, while serendipity plays a huge role in the outcome, there are ways that you can influence the picture.

WHAT YOU NEED

- Point-and-shoot or digital SLR camera with self-timer and Shutter Priority mode (see WARNING first)

WARNING

Camera tossing involves the possibility of permanent camera damage if you fail to catch the camera, or if it doesn't land on a very soft surface, so this might not be a technique to try out using a top-of-the-line digital SLR! Instead, look for a cheap secondhand point-and-shoot camera to practice with.

USEFUL TIPS

Camera tossing is often done in dark or dimly lit settings with bright light sources nearby. The contrast between the light and dark and pinpoint lighting creates the strongest images, like those shown here.

Try inverting the colors of your camera-toss pictures in your image-editing software for interesting results.

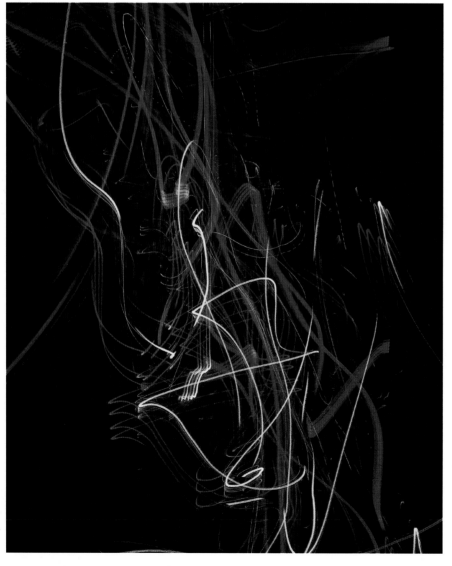

STARTING OUT

Two things have the greatest effect over your camera-tossing shots—the length of the exposure, and the speed of the toss. Both of these will determine how much blur there will be, but there are no hard-and-fast rules. You want to set a reasonably slow shutter speed—start with shutter speeds of around 1/4 sec—but it's worth experimenting with longer (and shorter) shutter durations as well. The easiest way to do this is to set Shutter Priority mode, and dial in the shutter speed you want to use.

When it comes to tossing your camera, you want to *gently* throw it into the air, ideally so it tumbles end-over-end, spins, and rotates in the air—all kinds of techniques are possible, and ultimately it's all about seeing what works best for you. Before you toss the camera, start the self-timer. Generally, camera tosses work best when the shutter opens and closes while the camera is in the air. It may be possible to do this if your digital camera has an extremely long shutter lag, but using the self-timer is more reliable, ideally setting it to 2 seconds if you have this option. Try and time your toss so you throw the camera into the air just before the shutter opens. If you throw it too early the shutter might not open "in flight," while leaving it too late might mean the exposure is over before the camera has left your hand.

The final part of the process is to CATCH YOUR CAMERA! It's a natural first instinct to hold onto the camera strap, or attach a wrist strap or similar when you toss the camera, but this will affect the spin of the camera and limit the results you get. Besides, camera strap attachment points aren't always that strong and could actually break from a sharp tug. So toss the camera untethered, put something soft on the ground as a safety precaution, and practice your catching!

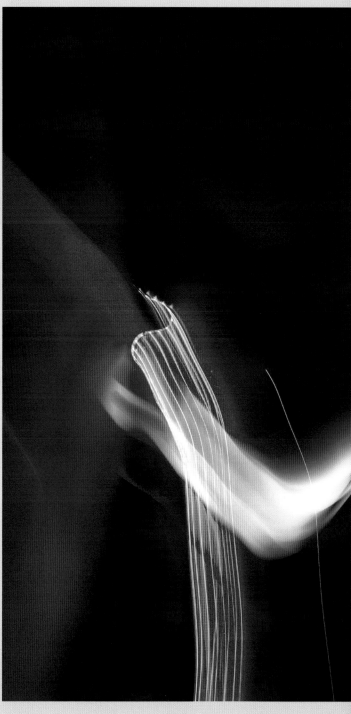

LEFT & RIGHT Camera tossing works well when the camera is thrown in front of a small, bright light source, as in both of these images. The contrast and color can intensify the abstract results.

#11 PANNING FIXED SUBJECTS

Photography treads a line between art and science, and panning is one of those circumstances where a little of both is required. In motor racing, panning has become part of the visual language for photographers, where tracking a moving subject can produce a crystal-sharp centerpiece against a texture of soft streaks. The science is based on setting the most appropriate shutter speed, while the art centers on the panning, action with the aim of moving the camera in harmony with the subject. But what if we were to tip the balance in favor of the "art," panning the camera not only on moving subjects, but on a fixed subject? Suddenly a short pan across a visually rich subject, such as the mottled texture of a leafy forest, creates an altogether more stirring interpretation of the scene, adding an impressionistic touch to the shot the moment the shutter closes.

What we're doing in this project is introducing motion blur where there is no motion. Creating a motion blur of any kind—be it through moving the camera or because your subject is in motion—requires you to bring the shutter speed under your control. The best way of doing this is to use your camera's Shutter Priority mode, as this will let you set the shutter speed you want, while your camera chooses a suitable aperture. When you're following a moving subject, shooting at $1/60$ sec for faster-moving objects and $1/30$ sec for slower ones is usually recommended, but when you are panning for more artistic reasons there's greater flexibility, as you do not need to worry about perfect sharpness anywhere in the frame.

To take your creative panning photographs, set your camera up on a tripod (or a sturdy support), switch to Shutter Priority mode, and select a slow shutter speed. Choose a shutter speed of $1/4$ sec or longer to start with, as this will give you enough time to move the camera during the exposure to create your motion blur. Now, loosen your tripod so you can move the camera fairly freely. You can either do this so the camera can only move horizontally across the frame, or vertically, or both, but consider the subject—with naturally vertical subjects, such as trees, a vertical pan will enhance their form, while a horizontal pan can blur it beyond recognition. Trigger the shutter and, while the exposure is being made, move the camera. The movement can be smooth and slow, or quick—it all depends on how much blur you want and the shutter speed you're using.

DIFFICULTY ★

WHAT YOU NEED

- Point-and-shoot or digital SLR camera with Shutter Priority
- Tripod (optional)

USEFUL TIPS

For added depth, create multiple pans of the subject, moving the camera in different directions. Overlay the images in your image-editing program to create a painterly effect.

BELOW LEFT A sequence of rapid pans from the same spot have been layered in Photoshop to create a painterly effect in this woodland scene.

BELOW A long, 1-second exposure was used here, and the camera was panned horizontally on a tripod.

RIGHT Panning creates a spooky atmosphere in an artificially lit, low-light environment..

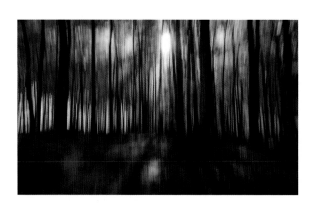

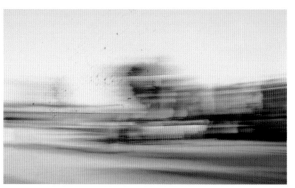

#12 HIGH-SPEED WATER DROPLETS

High-speed macro photographs of water droplets can look fantastic, especially when they're used to create stunning large-scale prints. However, it's something that looks—and sounds—like it's going to be incredibly difficult to do, and a lot of people think that to achieve a good result you need the most expensive camera, the most sophisticated flash system, and a bunch of specialist gear. But this simply isn't the case—the main ingredient for water droplet photography is good old-fashioned patience, which is the only reason this project has the maximum difficulty rating.

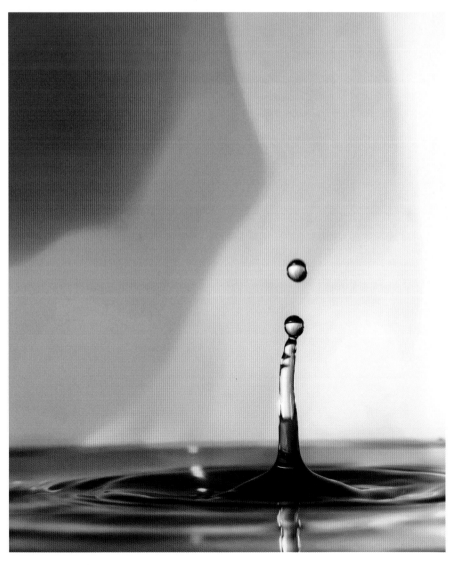

WHAT YOU NEED

- Point-and-shoot or digital SLR camera with Manual exposure control, manual focus, and macro lens/extension tubes/close-up setting
- External flash (optional)
- Tripod (optional)
- Remote release (optional)
- Water dropper (or turkey baster)
- Container for water to fall into
- Colored background (optional)

BEAM SPLITTERS

If you start to take your water-drop photography seriously, then you might want to consider getting (or making) a beam splitter. The sophistication of these devices varies, but the principal is basically the same—an invisible beam is projected across the water-set and when a droplet breaks the beam, the camera is triggered automatically after a predetermined time that can be measured in fractions of a second. By carefully working on the position of the beam splitter and the delay before the camera fires, the whole process becomes much more controllable, to the point that you can consistently record the perfect crowns or droplets. However, while it makes the process more predictable, some would say it turns the art of serendipity into a science.

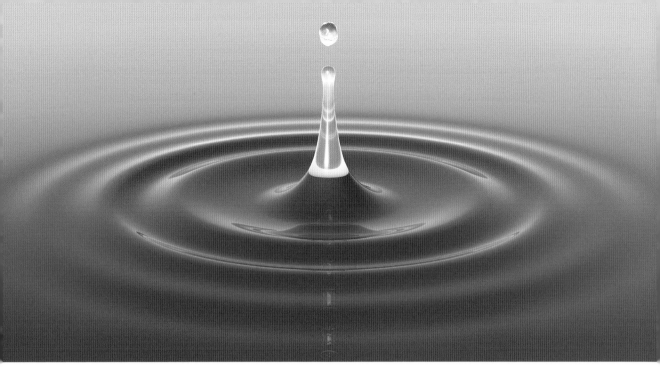

THE SETUP

Start by positioning a container of water on a table. This is where your water droplets are going to be formed, and you can use anything you like, from a fish tank to a glass, but consider if you're going to see any parts of the container in shot. If you are, then choose something that's going to be in keeping with the picture. Also think about the color of the container, as this can have a significant impact on your final image, especially if it appears in the shot, or as a background.

With your container in place, set up your camera. You can shoot water droplets hand-held, but attaching your camera to a tripod is strongly advised, simply because it means you can set a focus point and it won't change due to camera movement.

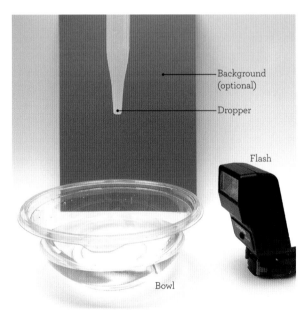

Background (optional)

Dropper

Flash

Bowl

The key controls you need on your camera are manual exposure and manual focus. In addition, you need to be able to focus closely, and a dedicated macro lens on a digital SLR is the best solution, followed by extension tubes or close-up lenses. If you're using a point-and-shoot camera, then you'll need to use its macro or close-up mode.

Switch to manual focus, and pick a point in your container where you expect your drops to be—in the middle is usually a safe option. Hold a pencil, or something similar, just above the surface of the water in this position and focus your camera. It can help to have someone hold the object for you while you focus.

#12

EXPOSURE SETTINGS

The basic exposure criteria for water droplet photography is a fast shutter speed, a small aperture, a low ISO, and plenty of light. And that means switching to your camera's Manual mode.

To keep your droplets sharp, set the camera's shutter speed to the maximum flash sync speed, which is usually $^1/_{125}$–$^1/_{250}$ sec. Set a small aperture of $f/11$–$f/22$ so you get good depth of field (this is useful as the droplets won't all be in the same place, and close-up photography naturally gives a shallow depth of field), and finally set a low ISO for the smoothest results.

Flash is the best option to light the droplets as it produces a short, sharp burst of light that will help freeze the water. You can use your camera's built-in flash, but an external unit is better. Not only will it be more powerful, but you also can position it off-camera and close to the water so you get enough light for your fast shutter speed, small aperture, and low ISO combo. Fire off a few test frames to get the exposure right, increasing or decreasing the flash's power, or moving the flash closer to or further away from the water until it produces the right amount of light to match your camera settings.

SHOOTING

Now comes the hard part! Using a water-dropper (a turkey baster will also do just fine), drop water into your container, aiming as best you can at the area you focused on. As you do, shoot like crazy! A remote release will help here, because you can drop water and shoot without worrying about knocking the camera. Using your camera's continuous shooting mode may also help if your flash can recharge fast enough. Where the droplet is when the camera is triggered will determine whether you get a drop, a splash, or a perfect crown—the key is to just keep shooting and hope you capture the perfect moment.

With water droplet photography, timing is everything, and this is why you need a whole stack of patience—for every hundred shots you take you might only get one or two good ones. However, with practice your timing will improve, and your hit rate will increase.

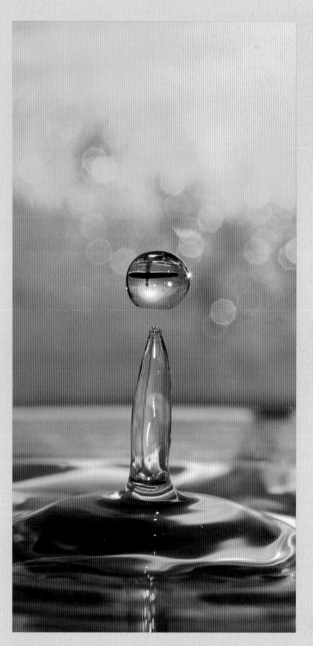

ABOVE Using a colored background is a great way of introducing color to your water shots.

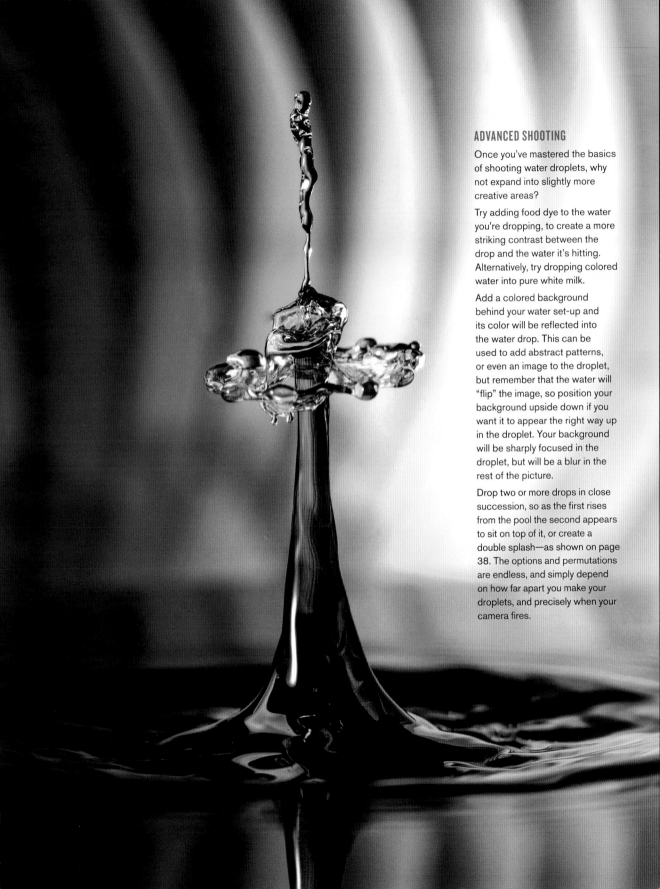

ADVANCED SHOOTING

Once you've mastered the basics of shooting water droplets, why not expand into slightly more creative areas?

Try adding food dye to the water you're dropping, to create a more striking contrast between the drop and the water it's hitting. Alternatively, try dropping colored water into pure white milk.

Add a colored background behind your water set-up and its color will be reflected into the water drop. This can be used to add abstract patterns, or even an image to the droplet, but remember that the water will "flip" the image, so position your background upside down if you want it to appear the right way up in the droplet. Your background will be sharply focused in the droplet, but will be a blur in the rest of the picture.

Drop two or more drops in close succession, so as the first rises from the pool the second appears to sit on top of it, or create a double splash—as shown on page 38. The options and permutations are endless, and simply depend on how far apart you make your droplets, and precisely when your camera fires.

#13 LEVITATION

Levitation shots present the viewer with something unexpected, which instantly makes them appealing, but they need to be done well if you want the viewer to suspend their disbelief and accept the subject floating in the picture before them. The best levitation photos are those that are truly believable, and in order to make them believable you have to take everything into account when you make your exposure(s): If there is movement, which way is the hair/clothing going to be moving? What is the lighting going to be like? Should there be a shadow beneath your subject? What shape is the shadow going to be? And so on... If everything has been thought about, then you are more likely to get a good result!

DIFFICULTY ★ ★

WHAT YOU NEED
- Digital camera
- Image-editing program with Layer masks
- Tripod

NOTE
Although you can cut-and-paste a subject from any shot and place it into another, you will find that the best results are achieved when you place your model in the actual background that you are going to use in the final image. The lighting will be totally realistic and this not only saves you editing time, but also produces the most convincing results.

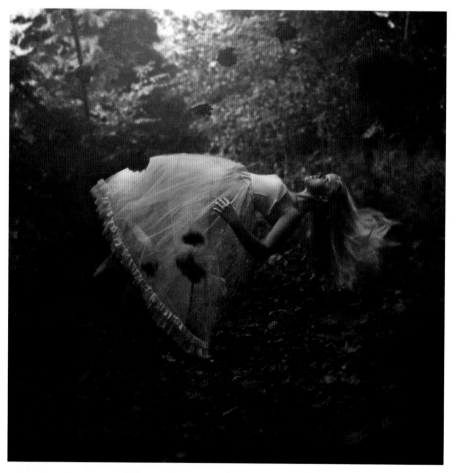

LEFT You don't need masses of gear to take successful levitation shots, but you do need a bit of skill if you want your levitations to be as convincing as this one.

SHOOTING

The basic process for a levitation picture is straightforward: take one photograph of the background, without the model in it, and another photograph with the model posed on a stool or platform. You then edit the two together in your image-editing program.

However, while this suggests that much of the work is done on the computer, the shooting stage is absolutely vital in getting the best material to work with. For a start, a tripod is essential if you want to create a believable levitation, as it will make sure that the camera doesn't move between shots. It's a good idea to work manually as much as possible, because if your focus and exposure don't change between shots, it will make your post-production work much easier.

Start by taking one shot of the scene without your model in it, making sure that the area you intend your subject to occupy is in focus. This will be your background shot. Then, bring in your subject and have them pose on a chair, stool, or other support, in a way that suggests they are floating. It doesn't matter if you can see the legs of the stool (these will be removed digitally), but it is very important to pay attention to the details noted above. You may even want to consider taking more than one shot of your subject. If you want to create the effect of someone falling, for example, you might want to take one shot of their hair moving, another of the dress movement, and a third exposure that records their pose, all the while making sure that they remain as still as possible. Either way, you should have at least two shots to combine: one containing just the background and the other containing the subject.

EDITING

The main editing tool used for levitation shots is Layer masks, which allow you to reveal and conceal parts of an image. Layer masks are a feature of numerous editing programs, but in this example I'm using Photoshop.

1 The first step is to select the Lasso tool from the toolbar and draw round the person you want to "levitate." When you've made your selection press Ctrl+J (Cmd+J if you are a Mac user) to make the selection into a new Layer.

2 Drag and drop this layer onto the background picture (the shot without the model or stool), making sure to match it up with the background in terms of its position. If you used a tripod your layers should line up perfectly, and if you hold down the Shift key while you drag the layer across it should snap to exactly the right point on the new background.

Add a Layer mask to this layer (*Layer>Layer Mask>Reveal All*) and you will see a small white box appear next to the layer thumbnail in the Layers palette.

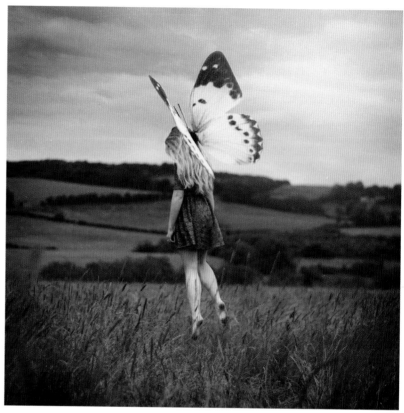

3 Select the Brush tool from the toolbar and set the foreground color to black. Making sure that you have selected the Layer mask (white box), you can paint over the parts of the layer that you don't want, allowing the layer underneath to show through. If you accidentally remove part of the layer, change the foreground color to white and paint the mask back in.

When you're masking areas such as legs and arms, it's a good idea to raise the hardness of your brush a little so the edges aren't as fuzzy (no one wants fuzzy legs!). After erasing the edges, assess your image. In some cases it will be good as it is, but in other images—including this one—it still looks as though the model is standing on something (even if it is invisible). To remedy this, I'll be taking the legs from another picture where they had been held up.

4 Using the same technique as Step 1, use the Lasso tool to cut out the leg from another picture and copy it across to the main image. Create a new layer mask for this layer and erase everything around the edge of the leg.

I repeated this process for the other leg and continued to make small adjustments to all of the layers. For this picture I wanted to make it look as though a butterfly was holding the subject up, so I also took a picture of a model butterfly close up and pasted that into my main image (above).

RIGHT A number of different exposures were needed to build this fantastical levitating scene, including individual shots of the flying books.

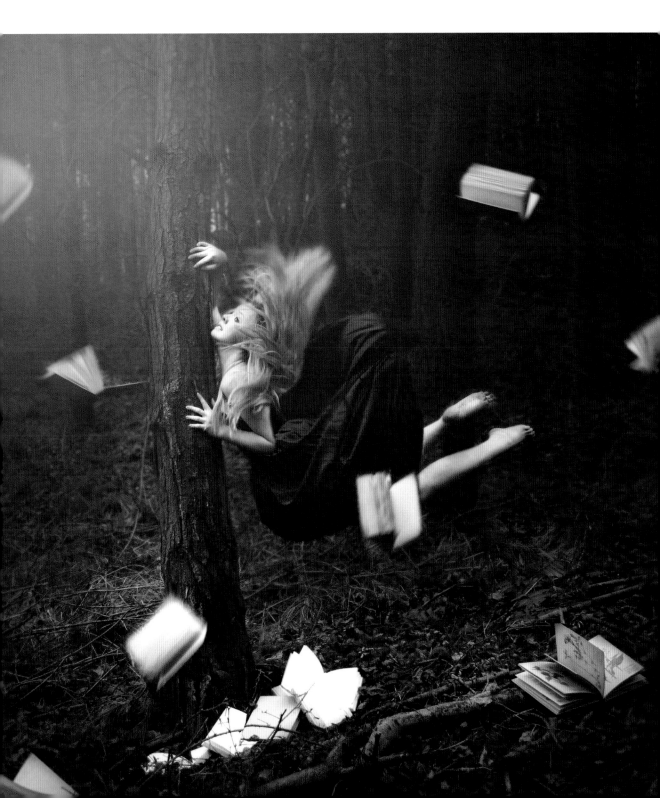

#14 INFRARED

Infrared (IR) light is invisible to the human eye as it is beyond the visible color in the spectrum. However, it is not beyond the recording range of a digital camera. This means that a camera can be modified (or a filter can be used) to capture infrared images, transforming a regular scene into something totally unexpected, sometimes even magical.

BELOW Infrared turns a lush green park scene into a dream pastel wonderland.

WHAT YOU NEED

- Modified digital SLR or digital camera with infrared filter
- Tripod

USEFUL TIPS

Point-and-shoot cameras often have weaker IR-blocking filters than digital SLRs, so allow more infrared light through to the sensor. Cheap brands usually allow even more IR light through, enabling you to add an infrared filter and shoot with shorter exposure times.

INFARED FILTERS TIPS

The following is a simple step-by-step "recipe" for shooting IR images with a filter:

1. Mount your camera on a tripod
2. Set the camera to Manual (M) mode
3. Shoot Raw files
4. Use an aperture of f/5.6–f/11
5. Set the ISO to ISO 400 or 800
6. Focus and frame your shot without the filter
7. Attach the IR filter
8. Set the exposure time to 10 seconds as a start point
9. Take your shot, check the histogram, and adjust the exposure time accordingly

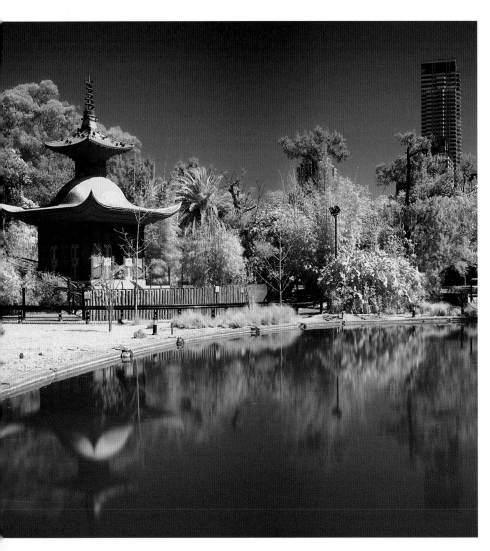

MODIFIED CAMERAS

The majority of digital cameras use some form of infrared-blocking filter. This filter is used to prevent infrared light causing unwanted color shifts in regular photographs, which is great for standard shots, but it means that most of the infrared light that the camera could potentially record is blocked. One solution is to remove the infrared-blocking filter in front of the sensor and replace it with a clear filter. The process of removing the IR-blocking filter can be done by several companies and is the preferred option for infrared photographers. However, while removing the IR-blocking filter will enable your camera to record infrared, it will no longer be suitable for regular photography—it will *only* be capable of shooting infrared. For this reason, many IR photographers will invest in a second camera body, specifically for IR conversion.

UNMODIFIED CAMERAS

Although most cameras have an infrared-blocking filter in front of the sensor, these filters are not perfect and they don't prevent all of the infrared light from reaching the sensor. This means that a specialized infrared filter can be used on the lens that will allow only infrared light to pass through. The results are similar to those you would get with a modified camera, but you don't lose the ability to shoot regular photos—you can simply remove the filter as you would a polarizer or any other filter.

Of course, there is a disadvantage, otherwise everyone would choose this option rather than permanently modifying their cameras. The problem is, using a filter will extend your shutter speeds considerably, which doesn't happen with a modified camera. Depending on how strong your filter is, exposures of several seconds—sometimes even minutes—may be required to record an IR image, so there is little chance of shooting handheld. There is also a very high chance of motion blur caused by the slow shutter speed.

INFRARED FILTERS

Assuming you don't want to modify your camera, you will need to get an infrared filter. There are several types available, which filter different levels of visible light: the cut-off point of the filter is measured in nanometers (nm). Visible red wavelengths of light occupy the range 620nm–750nm in the spectrum, which means that any filter with a cut-off point below 750nm will also allow some visible light to pass through. Filters with a cut off above 750nm will only capture infrared light. This is an important difference: If the filter allows both visible and infrared light then your final result will be a "false-color" photograph, while if the filter only allows infrared light to pass through, the result is a black-and-white photograph. One of the most popular filters is Hoya's R72 (720nm) filter, which allows some visible light through.

Taking a photograph with an infrared filter is similar to taking a regular shot, but there are some twists. For a start, you will not be able to see the scene through the viewfinder or Live View due to the filter's opacity, so you need to frame your shot and adjust the focus before attaching the filter. There is also a small focus shift between visible and infrared light, which needs to be compensated for. As most modern lenses no longer have an IR focus mark, the easiest way of doing this is to use a generous depth of field, so set apertures such as *f*/8 or *f*/11 for landscapes to make sure your focus will be fine.

With regards to the exposure time, this will need to be calculated by trial and error, so it's very important to check the RGB histogram after the shot: the red channel should appear overexposed and the green and blue channels underexposed. This is because your filter is letting some visible red light through, meaning your red channel is exposed more quickly during a long exposure than the green and blue channels that are capturing infrared light. If your red channel is clipped entirely then you will get a pure infrared photograph with no visible light. The aim is to expose as much as possible for the blue and green channel, while leaving some light in the red. The result will look very blue, but that's OK—you'll fix that at the post-processing stage. In fact, white balance is really difficult to handle in infrared photography, so rather than try to correct your images in-camera, shoot Raw images that can be adjusted more easily.

#14

PROCESSING

The first step with your IR pictures is to adjust the white balance. Ultimately, this is an artistic decision due to the false color in the image, but a common procedure is to use grass or foliage as a neutral color and adjust from there. If you want to be more precise you can take a shot of a gray card through your IR filter and use that as a reference.

Once the white balance is adjusted, the next step is to decide if you want your photograph to appear with blue hues or red hues. To change from one style to the other you have to swap the red and blue channels: there are actions for Photoshop and other editing programs that will do this for you. Again, this is an artistic decision, but if you were wondering why your shots were blue and many others were red, you just found the answer!

Infrared photos are usually very low in contrast, so this also needs to be corrected (Auto-levels is usually sufficient), and you will probably want to deal with noise too. All infrared shots are noisy (because the green and blue channels are usually underexposed), so running good noise-reduction software is therefore an important part of the processing.

NOTE

Not all digital SLR lenses are suitable for IR photography. Due to their optical design, some lenses will produce a "hotspot," which is a very distracting patch of light in the center of the lens. For example, the Canon 50mm *f*/1.8 lens is fine for IR work, but the Canon 50mm *f*/1.4 is not.

Infrared filters above 850nm are very specialized and mostly used in forensic applications. They can be used creatively to produce black-and-white images taken with only infrared light (right), but you will need really long exposure times: a digital SLR fitted with a 900nm filter is likely to require an exposure of 10–20 minutes at a relatively low ISO setting.

#15 PAINTING WITH LIGHT

The word *photography* comes from two Greek words that translate roughly as "light paintbrush" or "light drawing," but it is more commonly translated as "painting with light." As photographers, we rely on the reflection of light in a scene to help us create images that capture a moment in time. More often than not we look for spectacular natural light, such as sunrises, sunsets, dramatic skies, or even the man-made light that illuminates a nighttime scene. However, we also have the ability to illuminate a scene as we see fit, in much the same way that painters can produce their own interpretations of a scene. This is most apparent when using studio lighting for a portrait or a product shot, but artificial illumination doesn't have to be restricted to the studio. With flashguns, torches, LEDs, and even lasers, you can illuminate an exterior scene in any way you choose, creating your own version of reality. This is the true, creative interpretation of painting with light.

DIFFICULTY ★ ★ ★

WHAT YOU NEED

- Digital SLR camera with B (Bulb) setting
- Flashlight, flash, or similar
- Tripod

BELOW Location combined with light painting can be used to create some seriously atmospheric images.

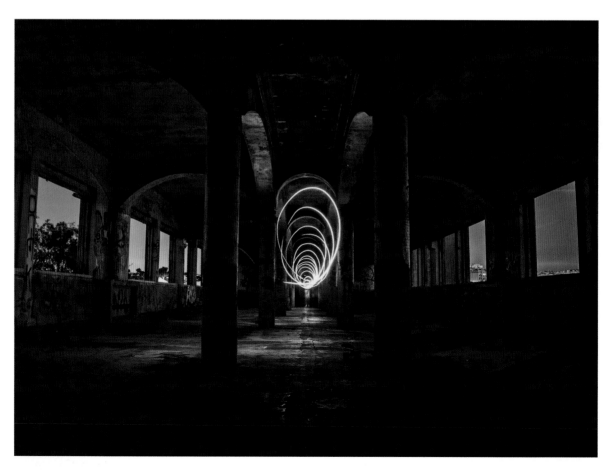

WORKING OUTSIDE

Just like a painter, to be a able to paint you need to start with a completely blank canvas. As photographers, this "canvas" needs to be black so that you can add, or "paint," the light onto the image as you expose your film or sensor. Working at night gives you the perfect opportunity to do this. A flash is the most obvious light source to use—particularly if there are people in your scene—as it will freeze any motion, but it is possible to use just about anything that creates light.

Try to find an appropriate scene to illuminate, and think about which areas you want to light, how you want to light them, and even the colors you want to light them with. Using cold blues and greens in a woodland scene can make it seem like a fantasy setting, while using an assortment of lighting and colors on a steel and glass building can make it look like something from a science fiction movie. Colored effects can be achieved by using a colored gel over your flash or light.

If you are lucky enough to own multiple wireless flashes then it is possible to hide them around a scene to light various parts of the subject. Simply set the aperture to f/8 to start with, and fire your camera's shutter in B (Bulb) mode. Adjust the flash brightness until you get the result you are after.

With a single flash it is possible to achieve the same results, but you need to be prepared to do a little bit of running around. Set your camera on a sturdy tripod and take an ambient light reading to see how long it will take to expose the scene. Decide how much ambient light you want the scene to have (usually you will want to expose so that the night sky is not completely black).

ABOVE Using a colored flash can add extra dimension to your light paintings. For the shot below, a yellow-gelled flash painted the top and bottom, a blue-gelled flash was fired at the bars, and a red-gelled flash was triggered inside each of the cells.

Now, set your camera's exposure in Manual mode and, with the flash set to around 1/16 power, trigger the camera's shutter. Move around the scene, firing the flash to light up different areas while the shutter is open. It is best to wear black or dark clothing while you do this so that you don't become visible in the image. Make sure you don't fire the flash directly at the lens or it will show as a hotspot in the image.

After the image has been taken, see which areas have been properly exposed and which haven't. It may take a few attempts before you find exactly the right amount of light to use to expose each area, and you might find that you need to fire the flash a few times in and around one location, or that you need to increase the power of the flash. A fresh set of batteries, or even an external power supply for your flash unit may speed up the time it takes to recharge before you can fire the flash again.

The whole process can be quite hit and miss, and if you are covering a large area in only a short space of time it is a good idea to have a second person helping you fire another flash, or triggering the camera. Alternatively, set a small aperture and the lowest ISO setting so you get a longer exposure that gives you time to illuminate the whole scene.

#15

FLASHLIGHTS

A flash isn't the only way to light a scene, and a hand-held flashlight can be just as effective. Once again, start by taking an ambient light reading and set the camera's exposure to allow some of this light in to the image. Now, use a flashlight to light up parts of the scene. The flashlight will be a lot less powerful than a flash, so you will have to use a sturdy tripod and be prepared for long exposure times. Most digital SLR cameras will allow for up to thirty seconds before you have to use the B (Bulb) setting.

A flashlight is much more directional than a flash, and this lets you choose precisely what to light and what to leave in darkness. Use your flashlight as a paintbrush and paint the light onto the subject. Make sure you keep moving the flashlight so the lighting is smooth with no hotspots. Obviously, depending on the size of the area you are lighting you may need to vary the power output of any flashlight you are using, and maybe even use different flashlights, just as you might use different sized paintbrushes.

LIGHT STREAKS

As a child you might remember using a sparkler at night to make shapes and write your name in the air. Using a tripod and a long exposure, it is possible to capture these trails of light. You can use a sparkler, a flashlight, a lamp—any source of light will have some effect and help you paint a picture.

Once again, wear black or dark clothing so that you don't appear in the images, then turn so that you are shining the light in the direction of the camera, but not directly into the lens as this could introduce lens flare. Now paint your light trails. Try experimenting by using light to outline parts of a scene. Use a flashlight to draw around the outline of a car or tree, or draw outlines around everything in the scene using different colored lights. You could even use the light to draw cartoon-style characters, like the images shown here.

ABOVE The most interesting outdoor images often combine light painting with ambient light.

RIGHT Using a flashlight lets you paint light into parts of an image or, as shown here, point the light toward the camera and draw freehand images.

TIPS

Working outside, assistants can be useful. Not only can they help you fire the camera's shutter, they can help you run around lighting large areas. If you don't have anyone available to help you, use an infrared remote to fire the shutter. This lets you get into position to begin painting with light. If you are lighting a large area, every second counts!

Colored lighting gels come with some flashes, and can be placed over the light to produce different colored light. Lighting gels can also be purchased as plastic sheets and cut to size. If you are working on a tight budget, candy wrappers or plastic bags can even be used to change the color of the light.

#16 TTV PHOTOGRAPHY

Through the Viewfinder—or TTV—photography is a relatively recent technique that combines a cheap, pseudo-TLR (Twin Lens Reflex) camera with a modern (usually digital) camera. The concept is quite simple; you compose the image using the TLR camera and record the image that appears on its viewfinder screen with a digital camera—complete with all the dust, scratches, and darkened edges.

A TLR camera has two lenses: the top lens (the viewing lens) reflects a reversed, mirror image to the "ground glass" or viewfinder, while the bottom lens (the taking lens) is the one that has a shutter and actually takes the picture. In this technique, no film is used in the TLR camera, so the bottom lens (and the TLR's shutter) is useless for our purposes. This is important because it means you don't need to get a fully functioning TLR if it's only going to be used for TTV photography, so keep an eye out at secondhand stores, rummage sales, and online auction sites for a broken (and cheap) TLR.

Kodak's Duaflex camera and the Argus 75 are the models most commonly used for TTV photography, but don't pay too much as these old cameras are plentiful. And don't bother with ones that are in spectacular condition—the key to taking interesting TTV shots is the viewfinder, so as long as your TLR has a viewfinder, that's all you need! Besides, a screen that has all sorts of flaws, such as ground glass with rounded corners or some good old-fashioned dust and scratches, will make your pictures more interesting.

Once you've got your TLR camera, the next step is to connect it to your digital camera, using what TTV aficionados refer to as "the contraption."

DIFFICULTY ★ ★

WHAT YOU NEED

- Point-and-shoot or digital SLR camera
- TLR (or pseudo-TLR) camera

The Contraption:

- Corrugated cardboard or sturdy cardstock
- Electrical tape and/or packing tape
- Scissors or a craft knife

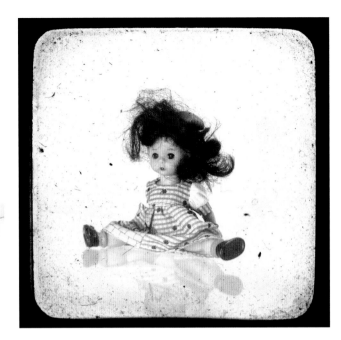

ESSENTIAL POST-PROCESSING

As most TLR viewfinders are square, and your digital camera shoots rectangular images, your TTV photographs will include the entire frame of the TLR's viewfinder, with big, black edges. So, open up your image-editing program and crop your image square, leaving in some of the TLR's edges. You might need to rotate it as well, and flip it since the TLR's viewfinder shows a reversed image (so left is right and right is left!).

After that, it's up to you whether you want to adjust the brightness, contrast, and color—or even convert your image to black and white for an added vintage feel.

THE CONTRAPTION

The contraption is a sturdy, light-tight connection that performs two roles in TTV photography: it physically connects your cameras together, so they are aligned and the correct distance apart, and it shields the TLR's viewing screen from light so you get the brightest possible image on the screen. Due to its low cost and rigidity, corrugated cardboard is the most commonly used material in contraption building, but when it comes to the contraption's design, there are no rules. Essentially, you are making a long rectangular box with an opening in one end to fit over the camera and a flap on the other end to insert the digital camera's lens into. Demonstrated here is a simple contraption to get you started. Note that I've fitted a 35mm SLR to the top of the contraption here, but that's only because I needed my digital SLR to take pictures of it!

ABOVE The TTV setup and the result—dust and scratches on the TLR camera's screen enhance the vintage feel.

#16

HOW BIG?

The first step is to determine the size of your contraption, and the main variable here is the type of lens you are using. A "standard" 50mm lens (or 50mm focal length setting on a zoom) will provide a minimum focusing distance of about 12 inches (30cm), but if you have a macro lens you could well be able to focus right down to about 2 inches (5cm). However, you need to make sure your chosen lens can capture the entire TLR viewfinder in the frame, so you need to do a simple test to find the length needed of your contraption.

Place your TLR camera on a flat surface, pointing at a well-lit subject so you can see the viewfinder image. Tape a ruler to the side of the camera, and get your digital camera out. Aim your digital camera at the TLR's viewing screen from directly above, and move it up and down until the TLR's screen almost fills the (digital) frame. Check that your digital camera will focus on the screen and then measure the distance between the two cameras.

Add to this measurement the amount of extra material you will need to fit around the TLR camera (the height of the camera is the easiest estimate), and add an extra bit so you have some room to fine-tune your focus.

Now that you know the height of the contraption, you can work out the measurements for the sides. Your contraption needs to fit around the TLR like a glove, which means measuring the outside perimeter of the TLR (sides, front, and back) and marking those distances down on your cardboard.

There are two things to note here: First, having your contraption fit a little loose is better than it being too tight (the looseness can be corrected with tape). Second, if you are using corrugated cardboard make sure the length (height) of the contraption follows the natural folds in the fluting of the corrugated cardboard—this will help the cardboard bend into a square to make the sides.

We're also going to add an extra flap to the top of the contraption to create a port for the digital camera. The length of the flap will be equal to the side of the TLR camera. The contraption template can now be drawn on our corrugated cardboard, with dotted lines showing where we will be folding instead of cutting.

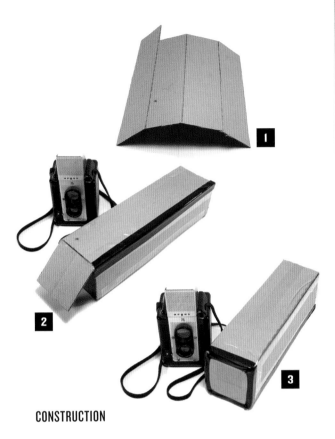

CONSTRUCTION

1. Cut out your contraption template and score the cardboard where you want it to fold. To make this easy, use a craft knife to cut through the top surface of the cardboard, but not all the way through. This will allow you to bend these areas as folds.

2. With the template cut out and scored for folding, tape the seams of the length together. Wide packing tape does the job well, but isn't light tight, so after putting on the clear packing tape, put a layer of opaque black tape on top to keep out the light.

3. Fold over the top flap and seal up these seams with opaque tape as well, using packing tape to offer some extra support.

#16

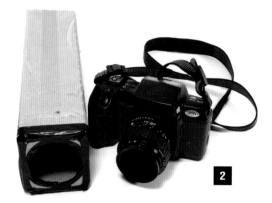

RIGHT TTV photographs have a distinctive, timeless quality. Many photographers using the technique add a cross-processed look to their images to enhance the "shot on film" appearance (see Project 44).

ADDING PORTS

With your basic contraption made, you can now make the port for your digital camera's lens and the TLR lens.

1 Start by taking your digital camera lens and tracing a circle around the circumference on the top flap of the contraption.

2 Cut out the hole, using tape to seal the edges—this is where you will insert your digital camera.

3 Slide your TLR into the bottom of the contraption and mark the position of the sides of the viewing lens. Measure the distance from the top of the TLR camera to the top of the viewing lens and extend the side marks by this amount, so you can cut out a port for the TLR's lens.

4 Slide the contraption onto your TLR camera and tape the two together—it should be a snug fit. Use your tape liberally, and consider going under the camera, as well as around it to hold the TLR in place. You're now ready to put the digital camera into the top and start shooting!

USEFUL TIPS

TTV shooting is awkward, and every photographer will develop his or her own preferred handling technique. Using a tripod to mount your TLR camera is the easiest option, as it gives you two hands to manipulate your digital camera. Another popular method requires you to hold the TLR in one hand and the digital camera in the other.

Set your shooting camera to autofocus, as it can be very difficult to focus manually and keep everything together, especially if your lens is in a port on top of the contraption.

Your digital camera's automatic exposure metering will read the black area around the TLR's viewfinder as part of the picture, so it's likely it will overexpose the image. If this happens, try using your camera's center-weighted metering mode, or decreasing the exposure using the exposure compensation feature.

Try attaching some close focus lenses (often called close-up filters), or holding the lens from a pair of spectacles in front of the TLR's viewing lens to get some really interesting close-up shots!

#17 LONG DAYLIGHT EXPOSURES

As photographers, we spend a lot of time and money getting as much light into the camera as we can, and "fast" lenses with large maximum apertures are both coveted and expensive. There are times when using these lenses to keep the shutter speed to a minimum creates fantastic results, recording split-second moments of time in a sports event, or freezing a crashing wave. Indeed, some water shots look best when the liquid flow is halted through an extremely brief exposure time, revealing each gleaming droplet suspended in the air.

However, it's also possible to go to the opposite extreme, lengthening the exposure time to transform moving water into a soft, veil-like surface. This is easy to do at night, when light levels are low, but how about in the middle of the day, when the sun is high in the sky and your camera wants to make exposures of fractions of a second? The answer is to use a neutral density—or ND—filter on your lens.

Neutral density filters are simply dark pieces of glass or plastic that reduce the amount of light entering the camera, and as you know, the less light you have entering the camera, the longer the exposure time. Because they absorb all wavelengths of light equally, they effectively darken the image without affecting the color in any way—hence "neutral" density—and it's important not to confuse them with gray filters. Although they look similar, gray filters are not specifically designed to be neutral, so may introduce a color shift to your images, as well as lengthening the exposure.

LEFT Using a tungsten white balance has added a cool blue cast to this long exposure of a small waterfall.

OPPOSITE Look to contrast sharp, solid landscapes combined with blurry moving features such as clouds, water, or tree branches in the breeze.

1 To make your long exposures you need to fit a neutral density (ND) filter to your lens. If all your lenses are the same diameter screw-fit filters are ideal, but if you want to use several lenses with different filter thread diameters it might work out cheaper to buy a square "system" filter-holder and adaptor rings for each lens. That way a single ND filter can be used with more than one lens.

2 Set your camera on a tripod and frame the scene. Remember that any moving objects in the view, such as clouds, leaves and branches, people, cars, and so on will all be blurred and, if the exposure is long enough, might even disappear entirely.

3 Set your camera to its lowest ISO setting and choose Aperture Priority mode. Select the smallest aperture setting (the biggest f/ number) as this will give you the slowest possible shutter speed. This will increase the depth of field (the areas in focus), but could also soften the image slightly as most lenses perform less well when stopped down too far.

4 You can let your camera work out the exposure for your long exposure shots because your camera's metering will automatically increase the exposure time to compensate for your ND filter(s). If you have one, use a remote release to avoid moving the camera when you trigger the shutter, or use your camera's self-timer to take the shot.

ND FILTER STRENGTH

Confusingly, the darkness of an ND filter is described by different manufacturers in different ways—this grid will help you cut through the jargon:

Darkening factor	Optical density	Darkening in stops	Percent transmission of light
2×	0.3	1	50%
4×	0.6	2	25%
8×	0.9	3	12.5%

Using this as a guide, you can see that a 2× or 0.3 ND filter will reduce your exposure by 1 stop and reduce the amount of light entering the lens by 50%. This means it doubles the exposure time, so a 1/60 sec exposure without the filter would be 1/30 sec with a 0.3 ND filter attached to the lens. A good starting point for this project is an 8× (0.9) ND filter, which reduces exposures by 3 stops, so your 1/60 sec exposure without the filter would become a subject-blurring 1/8 sec.

2
EQUIPMENT

As you saw in the previous chapter, there are lots of ways that you can get creative with your photography, simply by experimenting with your camera settings or photographing subjects that you hadn't previously considered.

Exploring different shooting techniques is definitely a step forward, but there's a time when we all feel that our camera is holding us back. The photographs we aspire to take often seem to have been captured by photographers with bulging kit bags that contain the latest camera and every possible lens and accessory that fits it. It's easy to conclude that to take the best pictures you need to buy a whole load of expensive gear and, if you can't afford it, it's even easier to start thinking that great, creative shots will always be beyond your means.

But you can stop thinking like that right now—you don't need a stack of money; imagination is the currency we're most interested in. In this chapter we're going to take a look at lenses and accessories. Some of them you can buy, but most of them you can make just as easily, and while some will solve more practical problems, they will all open up a world of creative opportunities.

#18 REVERSE LENS MACRO

DIFFICULTY ★ ★

WHAT YOU NEED

- Lens with a focal length of 50–135mm (can be a zoom)
- Manual 50mm lens
- Filter system adaptor ring for each lens
- Metal cement
- Clamps or clothespins

WARNING

Make sure you switch off your camera's autofocus system before using your macro combination. The added weight of the 50mm lens could damage the focusing motor in the camera or lens if you try to focus automatically.

TIPS

If you use your camera's zoom lens, you can use your camera's exposure metering system as usual with your macro combination—set your manual lens to its widest aperture first.

Don't focus using the telephoto/zoom lens attached to your camera. Instead, manually set the telephoto lens to its infinity focus setting and move the whole macro unit backward and forward to focus.

If you have never tried macro photography before, prepare to become hooked! Shooting the world in close-up opens a completely new chapter of tiny details and shapes in everyday objects that you never took the time to notice before. You can't really beat a good macro lens if you want to take macro photography seriously, but there are ways of making your current camera focus much closer without having to buy specialist and expensive equipment. In this project I'll show you how to use a low-cost, manual lens to magnify tiny objects. While it's not quite as flexible as using a proper macro lens, it's still capable of producing very high-quality results.

For this project you need a standard lens with a wide maximum aperture and a manual aperture ring so you can open the aperture as wide as it will go. An old, 50mm legacy lens is perfect. Once you've got your standard lens, it's simply a case of reversing it (so the front of the lens points toward your camera) and mounting it to your digital SLR's zoom lens or, in this case, a second 50mm legacy lens.

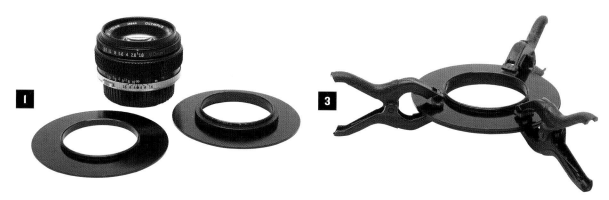

1 You're going to attach your lenses to each other using their filter threads, and to do this you need a filter system adaptor ring for each lens. The size you need will be written inside the front of the lens cap or around the front of the lens itself—most 50mm, *f*/1.8 lenses use a 49mm or 52mm screw thread.

2 Lightly sand the front, flat faces of the rings to roughen them, or score them with a sharp craft knife to create a key for the metal cement that you'll use to stick them together. Apply the cement to the flat side of one of the filter rings (the thinnest one if their sizes are different) and stick it to the flat side of the other ring so they are face-to-face.

3 Clamp the rings together to make sure they stick evenly, and let the cement set thoroughly, ideally by leaving the rings clamped together overnight.

4 Once your cement has set, fit your telephoto lens (or zoom) to your camera and screw the coupled adaptor rings to the front of it. I've used a 50mm legacy lens here.

5 Reverse the second lens, and attach this to the exposed filter thread on your camera-mounted lens. The assembly will be quite front heavy, but you now have a very useful macro lens. This combination focuses down to less than 1 inch (2cm).

#19 SUPER ND FILTER

By increasing your exposure times a neutral density (ND) filter can create incredible results, but they can be expensive, especially if you want to start stacking more than one filter for extreme exposure extension. However, if you have a spare screw-on UV filter (or filter adapter ring) and some strong adhesive, you're already ⅔ of the way to creating your own "Super ND" filter: all you need to add is a piece of welding glass.

As with regular ND filters, welding glass comes in different strengths, known as "shades:" the higher the shade, the less light passes through. A shade 10 welding glass is a good starting point for this project, as it will reduce the amount of light entering your camera by approximately 14 stops. You can get replacement welding glass from most welding supply stores, or online, and it doesn't cost a lot. The only downside here is that you're going to have to work on your images to get the color right: welding glass isn't "neutral."

MAKING YOUR "SUPER ND" FILTER

To transform your welding glass into a filter, you will need a UV screw-fit filter (or a filter system adapter ring) that matches the diameter of your lens, and some solid-setting adhesive putty. Give the welding glass a thorough clean in a solution of warm water and washing-up liquid, and allow it to dry before buffing it with a lens cloth. Then, simply use the adhesive putty to stick the welding glass to your filter (or adapter ring), working it around the edges to make sure you prevent any light leaks. Allow this to cure overnight and your super ND filter is ready for action!

DIFFICULTY ★

WHAT YOU NEED

- Replacement welding glass
- UV screw-fit filter (or filter ring adapter)
- Adhesive putty

NOTE

A major problem with long exposures is digital noise, and the longer the exposure, the more noise you will see in your final image. It is much better to shoot Raw files and apply noise reduction when you convert your images, rather than employing in-camera noise reduction and shooting JPEGs.

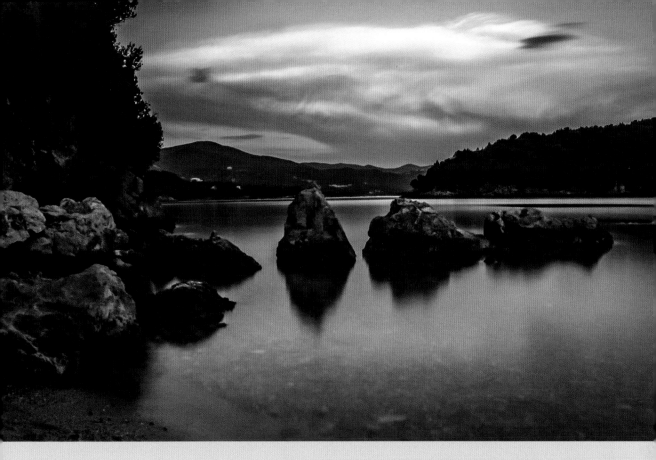

SHOOTING

The basic method of using your Super ND filter is no different to using a regular photographic ND filter. Start with the filter off the camera, so you can see as you focus and compose the shot. Then, select your camera's Bulb mode and the aperture you want to use, and make a note of the meter reading given by the camera. Set the lens to manual focus and hold the barrel still while you screw on your homemade Super ND filter.

Now comes the tricky bit—determining the exposure. Assuming you're working with a shade 10/14-stop filter, work out roughly how long the shutter will need to be open based on the initial exposure reading. For example, if the meter reading is $1/30$ sec without a filter, a 14-stop increase would extend this to approximately 500 seconds (roughly 8–8$1/2$ minutes).

It goes without saying that you need to make sure the camera is steady for the duration of the exposure. A tripod is essential and it must be on a solid surface. To hold the shutter open for what could be several minutes, set your camera to Bulb and use a remote release. You could hold the shutter-

ABOVE Your super ND filter can extend your exposures considerably: A shade 10 welding glass will reduce the amount of light reaching your sensor by 14 stops.

release button down manually, but this is likely to cause movement during the exposure. When you have finished, look at the LCD and histogram to determine if you need to adjust the exposure time and reshoot.

POST-PRODUCTION

Welding glass produces a strong green tint. You can try to counter this using your camera's automatic white balance setting, or by creating a custom white balance, but it's likely that you will need to use your editing software if you want to get an image with relatively natural colors. Adding magenta to your image will usually help balance it out, although you may also need to adjust the color temperature to get a more realistic hue. Shooting Raw makes this a lot easier than shooting JPEGs.

#20 IMPROVISED LENSES

The lens on your point-and-shoot or digital SLR camera is great for taking sharp pictures and keeping distortions and aberrations to a minimum, but who said every picture you take has to be technically perfect? Sometimes, "imperfect" pictures, whether they're softly focused, heavily distorted, or plagued by heavy fringing can have far more vitality, transforming a relatively mundane scene into something much more interesting. This project looks at a number of ways that you can deliberately degrade an image using improvised, low-tech lenses in front of your camera's usually high-quality optic. There are no fixed rules here, and some of the effects you might not like at all, but that's fine—it's all about thinking beyond your camera's "normal" potential and getting a little more creative.

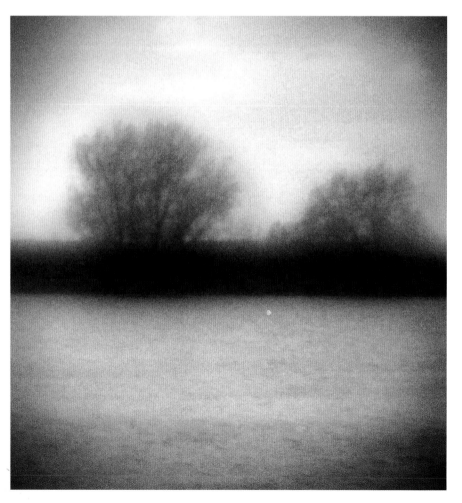

LEFT While this scene might have looked dull when shot with a normal lens, shooting with an improvised lens—with all the flaws that come with—fills it with atmosphere and a dreamy quality.

EYEGLASS LENSES

The lenses in your eyeglasses might help you see better, but on your camera they can help you take creative pictures. Simply pop a lens out of your glasses and use tape to hold it over your regular lens. The effect your eyeglass lens gives will depend entirely on whether it's designed to correct long- or short-sightedness, and the strength of the lens. For the picture on the opposite page, a monocle lens (near right) was used instead of an eyeglass lens for a soft, dreamy look, with slight vignetting. The images were cropped to create a look that's somewhere between a pinhole and a toy camera.

PEEPHOLE FISH-EYE

You don't have to spend a whole load of cash to get that crazy, round, fish-eye look—just head to your local hardware store and buy the widest peephole they sell!

If you're using a point-and-shoot camera, unscrew the two parts of the viewer and hold one end up to your lens for an instant fish-eye effect. It will help if you set the camera to its macro mode and zoom the lens in as far as it will go, but other than that, all you need to do is point and shoot.

Alternatively, if you're a digital SLR user, drill a hole in a spare lens cap and glue the viewer to it (above, far right). Tape the edges to stop any light from creeping in at the join, and stick the lens cap over your lens for the same wide-angle, fish-eye look. You'll likely end up with lots of black space around the circular image, but just crop this out with your editing software's cropping tool.

NOVELTY LENSES

Potential improvised lenses can be found in all sorts of places. The novelty "Leica" shown abpve cost around $10 from a museum gift store. The prism lens in it has great potential as an improvised lens, as shown by the image right. Simply hold your camera against the Leica's prism lens and push the shutter button for an instant kaleidoscope of color fringing and mini-images!

#21 DIGITAL PINHOLE LENS

Pinhole photography is the ultimate in low-tech, taking us right back to when man first noticed the properties of light. But, more than that, pinhole photography can produce fantastically creative images. In basic terms, when light travels through a very small hole it becomes focused a short distance behind the hole, so holes the size of pin pricks can be used in place of a lens. Of course, a pinhole lens doesn't rival the quality of a glass lens—it's not even close—but it can still produce very interesting effects.

The best way of making a pinhole lens for your SLR is to use a body cap (the cap that you would put on the camera if you didn't have a lens attached). This is because the body cap will fit your camera like a regular lens, is light tight, and is durable enough to be dropped in your camera bag alongside your normal lenses.

DIFFICULTY ✦ ✦

WHAT YOU NEED

- Empty aluminum drink can
- Heavy duty scissors (or similar) to cut the can
- Fine-grade sandpaper
- Eraser
- Narrow, sharp needle or pin
- Body cap for your SLR
- Drill with a $2/5 - 1/2$ inch (10–12mm) bit
- Glue

WARNING

You need to be very careful making your pinhole lens as you're going to cut open a metal can. The edges you will be left with are VERY sharp, so take care!

EXPOSURE GUIDE

If your camera cannot work out the exposure with your pinhole lens attached, set the ISO sensitivity to 200, the camera to Manual, and use the following exposure times as a starting point:

Bright Sunlight: 2 seconds

Hazy Sunlight: 4 seconds

Thin Cloudy: 10 seconds

Thick Cloud: 25 seconds

Indoors (brightly lit room): 5 minutes

Indoors (dark room): 1 hour

Night: Anything from 1 hour to all night!

BELOW Low-tech pinhole lenses offer us a totally new way to see and capture the world.

The start of your pinhole lens is nothing more exotic than an empty aluminum drink can. Empty the can and wash it out, then cut off one of the ends. Cut down the length of the can and remove the opposite end so you've got a sheet of aluminum. Leave it overnight under a few heavy books to flatten it out—this will make it easier to work with, and less dangerous.

Once it's flat, cut out a square from your aluminum sheet, roughly 1½-inch (4cm) square. Using your sandpaper, remove the paint from the painted side of the can. You don't need to do it all, just a small patch in the center where your hole will be made. Turn the can over and repeat the process on the other side to reduce the thickness of the aluminum.

Place your thinned aluminum lens panel painted-side down on an eraser. Using a "drilling" action, gently press the needle into the can until the tip of the pin goes through the metal. Only the very point of the pin should puncture the metal.

Hold your lens up to a light to see the hole you've made. If this is your first attempt, and the pin went all the way through (not just the tip), then it is probably too big. But don't worry—there's plenty of aluminum left on your sheet, so try it again!

5 Once you have your perfect round hole, place the lens panel painted-side up, and use your sandpaper in a circular motion to flatten off the slightly rough bump left by the pin coming through the metal. The hole will probably get filled with dust, so blow it and hold it up to the light again. You should now have a perfect pinhole lens, ready to attach to your body cap.

6 The first step in converting a body cap into a pinhole lens is to find its center. The easy way to do this is to draw around the cap on a piece of paper. Cut out the circle you've drawn and fold the paper into quarters. Line the curved edge against the edge of the body cap and the point of the paper will show you the center of the cap. Mark the center point.

7 Now, get your drill and make a hole in the center of the body cap to mount your lens. Use a large drill bit, and carefully drill through the center of the cap. The plastic is quite thick, so take your time.

8 Once you've made your hole, use your sandpaper to tidy the edges and remove any plastic burrs.

9 All you need to do now is simply glue your pinhole lens to the back of the body cap, keeping the hole as central as you can.

10 Once the glue's dry you're ready to fit the body-cap pinhole lens to your camera and start shooting!

USING YOUR SLR PINHOLE LENS

Most of today's digital SLRs have electronic connections in the camera body and the lens so the two can communicate with each other, but as your pinhole lens is nowhere near as sophisticated,there are a few things you have to do before you start shooting.

The most common problem is finding your camera won't fire with the pinhole lens attached. This is because without the electronic connections the camera might think there isn't a lens fitted. This is the same problem you might encounter using a homemade tilt lens (Project 28) and the solution is the same—look for a "shoot without lens" option, or similar.

You'll also find that the viewfinder image will be very dark; perhaps so dark that you can't see through it. This is because you're looking through a tiny lens that lets in very little light, but it's not something to worry about. One of the joys of digital photography is the ability to review the results on your camera's screen, so if anything's not quite right just take another shot!

The same rule applies to your exposures. Because your camera doesn't know what lens you're using it won't know what aperture to base the exposure on (with your pinhole lens it might be around f/150!) so it might not be able to work out the exposure for itself. The easiest way to get round this is to set ISO 200 and use the Exposure Guide on page 70. Set your camera to its Manual exposure mode (normally marked with an M on the mode dial), and set the shutter speed to "B" or "Bulb." This setting will open the shutter when you press the shutter release and—depending on your camera—it will keep it open for as long as you hold the shutter button down, or keep it open until you press the shutter release again. After you've made your exposure review the image on your camera's screen; if it's too dark, increase the exposure time or, if your first picture is too light, decrease the time.

#22 MACRO TUBE

There are numerous tools that you can use to enable you to photograph small subjects, ranging from relatively inexpensive close-up lenses that screw to the front of a lens in the same way as a filter, through to dedicated macro lenses or reversing your lens so you shoot through it back to front.

Alternatively, one sure-fire way to macro photography success is to move your lens away from your camera body, using extension tubes, macro bellows, or even a teleconverter to enable your lens to better record tiny objects. The idea of getting the lens away from the camera body is the basis of this project, which uses an empty potato chip tube as a low-cost "spacer."

BELOW The filament of a tungsten lightbulb, photographed using a homemade macro tube and the "wrong" white balance.

1 Before you begin you're going to need to collect the various items you'll need: a camera body cap (that you'll effectively trash); a lens (a manual 50mm prime is perfect); some black cloth (I'm using an old sock); and an empty Pringles tube (or similar).

2 Start by taking your body cap and coring out the center. You will be using this as the lens mount for your tube, so work from the inside and remove all of the plastic inside the mounting ring (as marked). Use a drill, or whatever else will do the job.

3 Place your lens cap on the metal end of your Pringles can and mark the hole you've cut out. Using your preferred cutting tool, carefully cut out the circle you've marked so you have matching holes in your body cap and chip can.

4 Take your glue gun or epoxy resin and mount your body cap to the chip can, aligning the holes you have cut in both. Clamp the two parts together while the glue dries.

5 The next step is to cut your chip can to length. As a rough guide, the longer the tube, the closer you will be able to get to your subject(s). However, as the tube length increases, you will lose light, which will lengthen your exposure times. This, coupled with the physically longer tube, will increase the chance of camera shake, so a small amount of compromise may be needed. For this tube I felt that a length of 6-inches/15cm would give me the best overall performance with my 50mm lens, although the measurement doesn't have to be precise.

6 To mount your lens to the tube, take your black cloth and wrap it around the lens barrel—how much cloth you need will depend on the diameter of the lens. The aim here is simple: you want to wrap enough cloth around the lens so that it fits snugly into your macro tube as shown. Try to make sure that the lens is relatively square in the tube.

#23 QUICK CLAMP

We all know how important it is to hold your camera steady when you shoot. It doesn't matter if you're shooting still images or recording movies, a camera that's moving around isn't likely to produce great material: still images will likely be blurred due to camera shake, while video footage can bounce around and make your audience nauseous. The traditional method for holding your camera still—beyond good camera technique—is to mount it on a tripod, or use a monopod or beanbag as a support, although in-camera image stabilization can also help if you're shooting handheld.

These are all great options, but they are not always that practical or versatile, which is where this project comes in: the quick clamp. Utilizing a large clamp, we're going to produce a lightweight camera mount that can be attached to railings, tree branches, or any number of othser objects, to guarantee rock-steady images or video footage.

Note that all small-format cameras (film and digital) use a 1/4-inch UNC tripod thread with 20 threads per inch. If you're looking for a suitable bolt, this is often written as 1/4–20 UNC, followed by the length of the bolt.

BELOW A quick clamp is ideal in the urban environment, especially in places where a tripod wouldn't be practical or allowed. In this example I used it to support the camera while I shot an HDR exposure sequence.

The main ingredient for this project is the clamp. I'm using the sort of heavy-duty plastic clamp that can be found in a hardware store: I got a cheap pack of 12 mixed sizes, including two of these giant, 8-inch long versions.

Take your drill and make a 1/4-inch hole at the top of one of the handles, near the end. I lucked in with this clamp: it already has a pair of small holes in the right place on each handle, so I just needed to make one of the holes larger. Because you're drilling plastic, this is pretty quick.

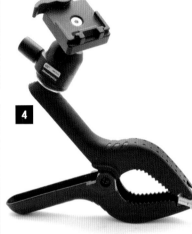

Next, fit your 1/4-20 bolt through the hole from the inside of the handle, and put the washer on the outer side. If you want to, you can attach your camera directly to the bolt at this stage—just use more washers to act as spacers between the camera and grip if you need to shorten the thread of the bolt.

Alternatively, attach a mini tripod head instead of your camera. You can often pick up small tripods secondhand for a couple of bucks—just make sure the head can be removed; is working; and has a 1/4-20 thread to attach it to the camera (some use a larger 3/8-inch thread).

With the head in place, you're good to go: just attach your camera, clamp it to a suitable and convenient object (think railings, tree branches, or anything similar to these), and you're guaranteed rock-steady images or video footage.

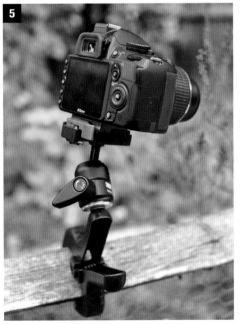

#24 REFLECTORS

In the studio, professional photographers have access to multiple strobes that let them direct light onto their subjects from all angles—be it a model in a fashion shoot, a portrait, or a still life. Our eyes understand shapes, depth, and three dimensions because we judge shadows and highlights to build a mental picture of what an object is like in real life. Lights of different powers are used to ensure we can see all the detail that is important, while still seeing that an object has shape.

Fortunately, you don't need lots of expensive studio strobes to use the same techniques in your own photography—you can use one light (be it the sun or something as simple as a table lamp) and a collection of reflectors to do the same job. Reflectors can act as additional lights when they bounce light, and using more than one lets you bend the light from a single source around your subject. They are also cheap and quick to make, and with a bit of imagination you can create all sorts of effects.

WHAT YOU NEED

- Aluminum foil
- Gold paper
- Stiff cardboard or cardstock
- Glue or tape

BLACK REFLECTORS

It might not be obvious, but you can use black reflectors in your photography. Rather than reflect light they will absorb it, so they can be used to darken shadows on one side of a subject, rather than lighten them. This is useful for adding definition to a portrait when the lighting is generally flat.

LEFT A small, handheld mirror has been used like a spotlight to make this flower stand out from the background.

WHAT DO THEY DO?

Reflectors are used to balance light and shade in an image. Your camera's sensor can only cope with a certain range of brightness, so you have to do something to stop shadow areas from being too dark for the camera to record, because all detail in that area will be lost. Imagine, for example, someone is sitting sideways by a window. The side of their face closest to the glass will be bright, and the side facing away from the glass will be dark—possibly too dark. The idea of using a reflector is to bounce some of that window light back at the person to add light to the dark side of the face and even up the brightness range. If you are taking portraits, deep shadows will also emphasize wrinkles and skin defects and are not very flattering.

There are many different types of reflectors that you can make, and each has it own characteristics. The "power" of your reflector depends on three things: how close it is to your subject, its color, and whether it is shiny or matte.

WHITE REFLECTORS

White reflectors are easiest to make, as all you need is something white and flat—a piece of white cardstock, a sheet of polystyrene, or even a newspaper. To make the reflector easy to use it should be solid enough to lean against something or hold without collapsing, so if you're using white paper, stick it to a piece of cardstock (or just use white cardstock). White reflects light well, so it produces a soft, neutral-colored reflection that is especially good for portrait photography.

ABOVE LEFT Outdoors, a white reflector can help balance out the lighting on the subject, lightening shadows for a softer, more natural look.

ABOVE Gold reflectors can enhance portraits by giving your model's skin a warm glow. You can vary the intensity by moving the reflector closer or further from the subject.

ALUMINUM FOIL REFLECTORS

Instead of white paper, stick aluminum foil to a sheet of cardboard instead. It will reflect much more light than white paper, but its effect is much cooler. The light can be harsh, so experiment with the foil laid out flat and also crumpled up, then flattened and stuck to the board. Silver reflectors are more commonly used for still-life photography than portraits.

GOLD PAPER

Reflective gold paper is great for portraits, either inside or out. You can choose between really shiny paper for a hard effect, or matte paper for a softer effect. The gold surface will create a warm light that emulates a sunset situation, adding a healthy glow to skin tones.

MIRRORS

Although you can't actually make them, mirrors reflect a lot of light and almost act as an extra light, rather than a reflector. Depending on the type you use they can appear as spotlights on your subject—make-up mirrors on hinges are great as they are easy to direct, or try using mirrored tiles for larger subjects.

#25 BEANBAG

Many photographers will agree that the most useful, yet overlooked item is a tripod. However, supporting your camera is important, so if you don't feel like carrying a tripod, why not take a beanbag instead? A beanbag can help hold your camera steady on the ground, on top of a wall, or pretty much anywhere else you can put it. There are lots of ways to make a beanbag, but the version here is one of the easiest because there's no sewing involved—I'll be using fabric fuse tape that you simply put between two pieces of fabric, heat with an iron, and it bonds the pieces together without sewing.

WHAT YOU NEED

- Thick cotton fabric
- Iron-on fabric fuse tape (hemming tape)
- Velcro
- Medium-sized bag of rice or lentils

TIP

If you're handy with a needle and thread, it's a good idea to sew the seams of your beanbag instead of using fuse tape, as this will make the beanbag more durable. You could also use a heavy-duty, waterproof fabric, but because this type of material tends to be plastic-based you will definitely need to sew it—using fabric fuse tape and a hot iron on plastic will just leave you with a sticky, melted mess.

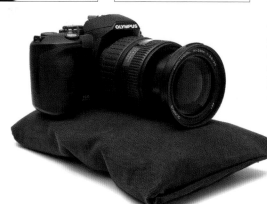

1 The first step is to cut a piece of fabric that will wrap around your bag of rice or lentils. Place your bag on the fabric and trace round it. Move the bag and trace it again so you have two rectangles that join along the long edge. Add two inches (5cm) all the way around so you have extra material to stick.

2 Cut your fabric out and fold it in half, with the inside of the bag facing out. Use fabric fuse tape to stick the two short sides together to create a "bag" that's sealed on two sides, folded on the third, and open at the top.

3 Turn the bag inside out, so the stuck seams are now on the inside. Make a couple of tiny pinholes in your bag of rice/lentils (so air can escape) and slide it into your beanbag.

4 Finally, add a strip of Velcro to seal the open end. You may find you have too much material, in which case just cut it or fold it inside to tidy it up.

#26 CAMERA SLING

A camera strap is pretty much taken for granted if you want to take an SLR camera or CSC out and about and have it ready to shoot at a moment's notice. However, the traditional attachment method—two eyelets on the top of the camera—can get in the way at times, especially with digital cameras and their numerous control points. A camera sling alleviates this problem by attaching to the bottom of the camera, utilizing the tripod mount to keep the strap out of the way of your buttons and dials. Worn diagonally across the body, from shoulder to hip, it can also make carrying your camera more comfortable as well.

DIFFICULTY ★

WHAT YOU NEED

- Strap from laptop bag, camera bag, or similar with rotating metal ends
- Small right-angle bracket/ corner brace
- 1/4-20 UNC bolt (approx. 1/2-inch long)
- 1/4-inch or 6.5mm drill bit
- 1/4-inch washer (optional)
- Thread-locking fluid (optional)

NOTES

Use a strap with metal and not plastic ends. Metal is much stronger so will increase the longevity of the sling.

A camera sling can also be used with a compact camera. This is more convenient than the wrist strap this type of camera often comes with.

1 Start by checking that your bolt will fit through one of the holes in the angle bracket. If it doesn't, use your drill with a 1/4-inch or 6.5mm drill bit to enlarge the hole. Make sure that the bracket is clamped firmly while you drill it, and don't forget your eye protection—a metal shard in the eye isn't fun!

2 With the hole enlarged for the bolt, check that your strap will fit the other hole in the angle bracket. You only need to make sure that one of the strap's clips fits the hole, but if it doesn't (or doesn't fit comfortably) you'll need to reach for your drill again. Take your time and use a slow speed setting to keep the friction (and heat) to a minimum—this will help extend the life of your drill bit.

3 Once your angle bracket is cool enough to handle, you can put your sling together. Start by bolting the angle bracket to the tripod socket of your camera, using a washer between the bracket and camera if you want to. I'm using a fiber washer here, simply because

I had a stash in my workshop. You can also use thread-locking fluid on the bolt to make sure it doesn't work itself loose.

4 Attach one end of the strap to the other to create a loop (I'm using an old-school Olympus camera strap for this project) and then clip the free end of the strap to the angle bracket on the camera. Adjust the length of the strap so your camera sits comfortably and you're good to go!

#27 LIGHT CUBE

It's widely accepted that if you want to get the best price for an item on an internet auction site such as eBay you need to have your item listed with a picture. And the better the picture, the more attractive the item will appear to potential bidders. It's not just internet auctions, though—any product photograph should look its best, and if you've ever struggled to control lighting, shadows, and backgrounds, you'll know the importance of even lighting and the frustrations involved in creating it. You can buy light tables, light tents, and light cubes that will all help you acheive the "perfect" product shot against a white background, but before spending a lot of money, why not try making a light cube yourself? This project will get you set for taking great product shots using materials that are extremely simple (and cheap) to obtain, and you might have most of them lying around already!

WHAT YOU NEED

- Cardboard box (size determines size of light cube)
- Three portable lamps (ideally with daylight-balanced bulbs), or flash units
- Masking tape
- Tissue paper/tracing paper/parchment paper (or similar)
- Large sheet of white paper
- Box cutter/craft knife/scissors
- Sheet of acrylic/Plexiglas (optional)
- Clear plastic cups or glasses (optional)

TIPS

You don't have to shoot everything against a white background—just replace the white paper in your cube with colored paper.

Try adding a colored gel over one of your side lights to add a splash of color. A light blue gel will work well with chrome or metal objects, enhancing the cold, metalic feel.

WARNING

To avoid the risk of fire, never leave your light cube unattended with the lights on if you use continuous lighting.

LEFT Final image

1 Position your box on a table so the opening of the box faces up, as shown. With a pencil or marker, draw guidelines on the two short sides to identify where you will be cutting. You don't want to cut too close to the edges as the box will become unstable, so leave at least 1½ inches (4cm) of cardboard all the way around your marked holes. Do the same for one of the larger sides, but extend the hole through the flap, as shown.

2 Use a box cutter, craft knife, or scissors to cut out the marked sections, so you are left with a box with open panels on three sides.

3 The next step is to cover the sides with diffusion material, to help even out and soften the lighting you use. Tissue paper, tracing paper, and parchment/wax paper are all good for this, and using two sheets of material over each hole will increase the diffusion effect. Cut sheets of diffuser to size, allowing them to overlap the sides of the holes, and stick them down with masking tape.

4 To add the background, cut a sheet of white paper to match the width of the box. Tape the paper to the top edge, inside the box. Let it curve gently onto the bottom of the box—do not press or fold it into the back corner—and tape the front down to hold the shape of the curve. This will create a "seamless" look to your pictures.

5 To light your products, position a lamp or flash unit on each side of the box, with a third light above. Allow the top flap to hang down slightly, as this will add slight frontal lighting. Assuming your lights are all the same power, or your flash units are set to deliver the same output, the result will be near-perfect, even lighting.

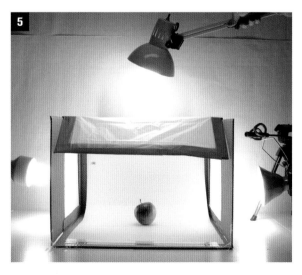

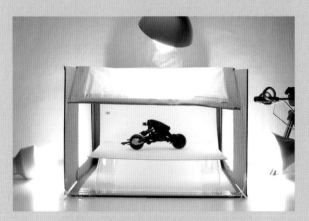

ADDING A FLOATING PLATFORM

The light cube will successfully eliminate most shadows, or at least minimize them so they are easy to touch up in an image-editing program. However, it is practically impossible to remove all of the shadows, particularly from objects that do not have a flat bottom. If it is essential that you remove these bottom shadows, try creating a floating platform that will allow light to reach the underside of the subject.

A simple floating platform can be created by taking a clear piece of acrylic/Plexiglas and covering it with a sheet of tissue on top. Put the platform in the light cube, elevating it with clear plastic cups or glasses, and place your object on top. Now, the lights from the side of the cube will also pass under the object, and the white background will reflect light up, reducing the shadows underneath your subject.

USING YOUR LIGHT CUBE

There's a certain amount of trial and error in using a light cube, mainly with the lighting, white balance, and exposure.

To produce a "true" white background, it's easiest to use a daylight-balanced light source, and set your camera to its daylight, or "sunny," setting. Flash is ideal for this, but buying three flash units can be expensive. Instead, try using desk lamps with screw-in "Daylight" fluorescent lightbulbs and set your camera's white balance to "Fluorescent Daylight." There is usually more than one fluorescent white balance setting available, so consult your camera's manual to see which one you should use.

For the exposure, set your camera to a low ISO setting (ISO 100 or 200) to minimize noise, and mount the camera on a tripod. This will free up your hands to manipulate the lighting when necessary and, in addition, use your camera's self-timer so you won't be touching the camera when it fires. This will reduce the risk of camera shake.

With your object, make a test exposure, and review the result. It is quite likely that it will look a little dark, because the brightness of the light cube will fool your camera into underexposing. Use your camera's exposure compensation (EV) control and dial in +1–2EV to lighten the exposure. Adjust the EV control until you get a pure white background.

Finally, don't be afraid to adjust the brightness and contrast in your editing program to fine-tune the result—once you've mastered using a light cube, your product photography will be flawless every time!

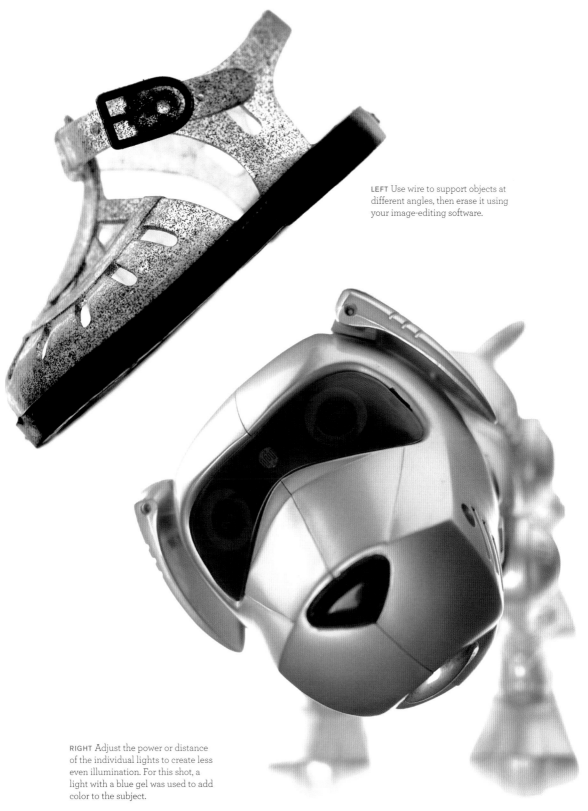

LEFT Use wire to support objects at different angles, then erase it using your image-editing software.

RIGHT Adjust the power or distance of the individual lights to create less even illumination. For this shot, a light with a blue gel was used to add color to the subject.

#28 TILT LENS

Tilt and shift lenses were originally designed to correct perspective distortion, particularly in architectural photography. Instead of being fixed, the lens can be tilted, so the front isn't parallel to the plane of focus (the film or sensor). By adjusting the angle of the front lens, the path of the light changes, which corrects the perspective. However, their ability to also change the focal plane in an image has long been used for more creative purposes. When the plane of focus is adjusted and used in combination with a large aperture, a very shallow depth of field is created, similar to that of a macro lens. But, with a tilt lens, the line of sharpness in an image can be manipulated, so instead of running horizontally across the frame it can run diagonally, or even vertically.

There is a downside, though—tilt and shift lenses are very expensive. Recently, the LensBaby appeared as a lower-cost alternative, offering photographers the chance to attempt selective focus photography for a more modest cost, but even the price of these has started to creep upward. However, with a little ingenuity and a few inexpensive items, it's entirely possible to make a great little tilt lens of your own.

DIFFICULTY ★ ★

WHAT YOU NEED

- Old medium format lens
- Body cap for your digital SLR
- Concertina-style sink plunger
- Thick black cardstock
- Black tape
- Ruler
- Scissors
- Craft knife
- Ruler
- Marker pen or Sharpie
- Drill or rotary tool
- Epoxy resin (or strong glue)

CHOOSING A LENS

Because you will be changing the direction the lens points in, you need to make sure your tilt lens produces a larger image circle than your regular digital SLR lens, and this means getting a lens that's designed for medium format photography. The low-cost option is to scour flea markets, yard sales, and internet auctions for an old medium format enlarger lens or bellows camera. As you only need the lens you don't need to worry about the condition of the camera, so save some money and buy a used example. Then remove the lens—it's usually only a couple of screws holding it in place.

1. There are three key ingredients for making your own tilt lens. In addition to a medium format lens, you will also need a rubber or plastic concertina-style plunger (this will provide the tilt mechanism), and a body cap for your SLR (which will be the lens mount).

2. Before you start to assemble your lens, the first step is to work out how far the lens needs to be from the camera's sensor. To do this, hold the lens close to a light-colored wall, facing an opposite window.

Open the lens aperture fully. Move the lens closer to the wall and then further away until the projected circle of light that's coming through it is sharp. Use a ruler to measure the distance from the rear of the lens to the wall.

In addition to this distance, you also need to know the flange depth of your particular camera, which is the distance from the lens mount to the sensor. This should be in your camera's manual, or on the manufacturer's website under "specifications." Subtract the flange depth from the focus distance you measured—the result is the length that your tilt lens needs to be.

3. Remove the handle from the plunger and, measuring from the narrow end, mark the tilt lens's length on its side. Cut around the circumference of the plunger at this point so you are left with a shorter "skirt."

4. Cut a small, circular hole in the top of the plunger that is slightly smaller than the diameter of your SLR's body cap.

5 Using a drill or rotary tool, cut out the center of the body cap so you are left with a plastic ring. It's best to do this from the back of the body cap so you don't accidentally cut off the mount itself.

6 Now it's time to glue the plunger to your body cap lens mount. A strong bond is needed, so score the parts with a knife or use abrasive sandpaper to roughen the surfaces. Glue the pieces together using epoxy resin and leave them overnight for a solid bond to form.

7 Once the glue has dried, trace around the wide end of the plunger onto a sheet of thick black cardstock. Cut the disc out, then make a hole in the center of the cardstock that is large enough to hold your lens. Glue the cardstock to the bottom of the plunger using epoxy resin and leave it to dry—this is going to be your lens panel.

8 When the card mount is firmly stuck, wrap black tape around the edges of the lens panel and the lens mount (body cap) to prevent any light leaks. You can paint it black to match, as I have done, but it's not essential!

9 Finally, attach the lens. Although it might stay in place using friction, it's better to glue or tape it in place. Once it's stuck, hold the end that will be mounted to the camera up to your eye. If you can see any light leaking in, now's the time to seal the holes with tape. Then simply mount your tilt lens onto your SLR as you would any other lens.

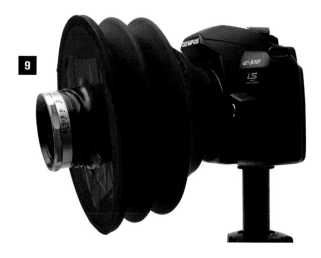

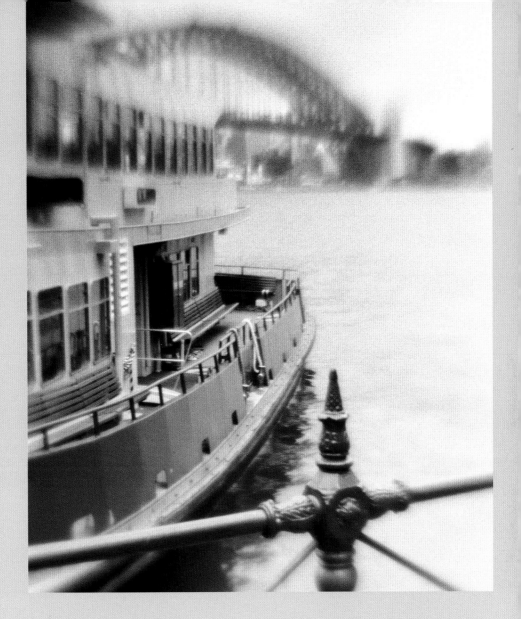

USING YOUR TILT LENS

With your tilt lens on your SLR, push and pull different areas of the plunger to adjust the focus in the image, keeping some areas sharp and letting other parts of the picture blur. It takes practice to master, but by twisting, pushing, bending, and pulling the plunger you will create some great-looking images. Because of the constant pressure you are applying to keep the image in focus, camera shake can be a problem, so use a fast shutter speed and try setting your camera to its continuous shooting mode so you take a burst of exposures that you can choose the best from.

When it comes to measuring the exposure, the first thing you need to do is make sure your camera will fire with the tilt lens attached. Because it won't recognize the body cap as a lens, look in the menu (or camera manual) for a "shoot without lens" option, or similar. Then, switch your camera to Manual, set the aperture on your tilt lens, and use the scale in the camera's viewfinder to set the corresponding shutter speed.

#29 SYSTEM LENS HOOD

You can have the finest lens on the planet, with the very best coatings, but it's still guaranteed that if light strikes the front element at a certain angle you're going to suffer lens flare. In the past, you'd simply fit the lens hood that came supplied with your lens and that would be that, but today it's not quite so straightforward: some manufacturers don't include caps with all of their lenses; the long focal length range of some zooms makes the supplied lens cap all but redundant (the negligible shade provided at the wide end becomes wholly ineffective when you zoom in); and, of course, lens caps get broken and replacements are expensive. Yet all it takes is a sheet of black foam board, some Velcro, and a filter system adapter ring, and you've got all the ingredients you need to start building a bespoke lens hood "system."

DIFFICULTY ★ ★

WHAT YOU NEED

- Black foam board
 (1 × 11 × 14-inch/A3 sheet)
- Pencil
- Pair of compasses
- Velcro
- Double-sided tape
- Filter system adapter ring
 (see Tips)
- Glue

TIPS

Use a filter adapter ring that matches the largest diameter lens in your collection, and fit stepup rings when you want to use it with smaller lenses.

A five-inch square/125mm mount is ideal for wide–to–standard focal lengths, but for telephoto lenses you may want to reduce the size to prevent the shade from becoming overly long.

NOTES

The reason for making the frame and attaching the shade with Velcro is simple: If you want to make a shade for another lens, you can simply repeat steps 6–7 and use the same mount.

For zoom lenses, consider making separate shade units for different focal lengths: with an 18–105mm lens you might want to make shades for the 18mm, 50mm, and 105mm focal length settings, for example.

1 Start by cutting a five-inch/125mm square out of your foam board and marking its center. You can find the center by drawing two lines diagonally from corner to corner: the point at which these lines intersect is the mid-point.

2 Take your pair of compasses and set the legs so they are slightly wider apart than the radius of your filter adapter ring (here I've set the compasses to 35mm for a 67mm filter ring). Draw a circle that is centered in your square piece of board and cut this circle out. Attach your filter ring to the camera and hold your black square of board against it, so that the top of the square is level. Make a pencil mark on both the board and filter ring so you can realign them at the next stage.

3 Stick the filter ring to your foam board square using double-sided tape. Centering the ring on the hole you just cut out, and align the marks you made in the previous step.

4 Cut another five-inch square out of your foam board, and then cut a four-inch square out of its center so you're left with a 1/2-inch wide frame.

5 Now you can make the hood itself. You need to know the optimum size for this, so mount your filter ring (and square black board) to your chosen lens and hold a ruler at the left (or right) edge of the board, pointing directly forward. Look through the viewfinder and slide your finger along the ruler until it enters the frame: that is roughly the size you want to make the sides of your lens shade.

6 Cut four rectangles of foam board measuring five inches multiplied by the measurement you noted above (here two inches) less around 20%. Once cut, trim two of these boards by a measurement that is equal to double the board's thickness (so trim off 3/8 inch if you're using board that's 3/16 inch thick, for example). This should be cut from the five-inch side of the rectangle, just so that there aren't any gaps when you join the sides together. Once cut, stick the four rectangles together to form a five-inch square box.

7 Glue your box to the 1/2-inch frame to create your shade, and attach this to the filter ring mount using a tab of adhesive Velcro in each corner. Your hood is now ready for action!

3
LIGHTING

Today we have the luxury of digital SLRs that can "talk" to the flash, and without any intervention it can determine the exposure for us, even when multiple flashes are used or we want to balance the flash with ambient light. So why, when it's been made so easy for us, is flash still so underused? Perhaps it's because you cannot pre-visualize flash as it only exists for a split-second, and if you're not sure what it's going to do, why bother wasting a shot?

Or maybe it's because when you slide a bigger flash unit into your hotshoe the result you get just isn't going to do the subject justice? But then again, harsh, direct, on-camera flash never will.

While there are valid reasons not to use flash, there are plenty more reasons why you should, and the main one is that it can make your pictures better—you just need to start using it more creatively.

In this chapter you'll find all the lighting accessories you need to do just that. For only a few hours of your time you can quickly transform your portable flash from the least-used item in your camera bag to one that's guaranteed to help you create stunning photographs.

#30 POP-UP FLASH DIFFUSER

On-camera flash is something of a paradox, with its positive traits balanced by negative aspects. For example, the built-in flash on most cameras is great when it comes to shooting in low-light conditions, but the low power means that subjects have to be close and/or wide apertures used if you want to get a good exposure without resorting to slow-sync flash. Similarly, as a fill light on a bright day your camera's built-in flash is often adequate, but use it as the primary light source and it will produce hard, unflattering shadows. Its close proximity to the lens is also likely to result in red eye, so it's not ideal for portraits.

However, it's incredibly easy to modify the output of a pop-up flash, and there are countless light-softening solutions. In this project we're going to make an ultra-simple diffuser for a pop-up flash that will take the edge off your hard shadows by scattering the light. The irony is that you need a translucent film canister to make this happen on your digital camera, so start by asking your local processing lab for a couple of canisters if you don't have them already—most labs will be happy to oblige.

DIFFICULTY ★ ★

WHAT YOU NEED

- Camera with pop-up-style flash
- Translucent film canister
- Ruler
- Craft knife

NOTES

Depending on your camera model, the diffuser may cause your flash exposures to come out slightly underexposed, so be prepared to dial in positive flash exposure compensation to increase the flash output.

Be aware that the diffuser may affect the color of your images. This can have a positive effect—if the diffuser warms the flash, it can make skin tones in portraits appear more pleasing, for example—but if you'd prefer neutral results you might need to create a custom white balance.

LEFT Unbelievably, this image was taken with a pop-up flash. It's the diffuser that makes all the difference.

1 With your translucent canister to hand, measure the height of your camera's built-in flash so you know what size to make your diffuser. To do this, pop up your camera's flash and hold a ruler in front of it, making a note of the measurement.

2 Mark two parallel lines running from top to bottom on your empty film canister. These should be slightly closer together than the measurement you took for the height of your flash, so if your camera's flash is 10mm high, space your lines 9mm apart. The reason for this is simple—it will be far easier to make the gap wider if needed, but much harder to make it smaller.

3 Cut carefully along the two lines with your craft knife and then across to make a rectangular slot in the film canister. Be sure not to cut all of the way to the ends of the canister.

4 You should now be able to push the canister onto your camera's built-in flash and it will hold by itself. If it's a bit tight, make the slot a little larger and try again. Keep the film canister's lid on to give the diffuser added rigidity and make it look more finished: use clear sticky tape to hold the lid on if necessary.

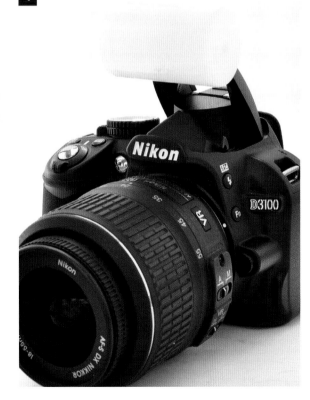

#31 PORTABLE RINGLIGHT

The must-have piece of gear for any aspiring fashion photographer is a ringflash, with its distinctive light quality. The circular shape of the flash—with the camera lens in its center—lets photographers get extremely close to a subject and create virtually shadowless images.

Originally designed for less glamorous uses—such as forensic, medical, and even dental photography—cutting-edge fashion photographers such as David LaChappelle and Nick Knight started to exploit ringflash lighting in their fashion and portrait photography in the late 1990s. The then-radical look quickly became very popular, inspiring a generation of fashion and portrait photographers .

Ringflash portraits are easily spotted, thanks to the tell-tale circular catchlight in the subject's eyes, as well as a shadow "halo" around the subject. A ringflash's even lighting also makes it ideal as a fill light to soften harsher shadows from other light sources, but the cost of a studio ringflash often puts this particular light out of the reach of most photographers.

DIFFICULTY ★ ★

WHAT YOU NEED

- Portable flash (off-camera)
- A large, shallow plastic bowl
- A smaller plastic bowl
- Aluminum foil
- Parchment/wax paper or tracing paper
- Black tape
- Epoxy resin (or other glue suitable for plastic)
- Scissors
- Craft knife
- Ruler
- Marker pen or Sharpie
- Flat black spray paint
- Thick cardstock

TIPS

If the light from your ringflash diffuser is uneven, or doesn't quite reflect all the way around the diffuser, lightly roughen the brighter area of the diffuser with sandpaper, or add an extra piece of your diffusion material to help even out the light.

Project 38 shows you how to create a larger ringflash diffuser for use in a home studio.

LEFT You can replicate the ringflash effect easily and cheaply using your existing portable flash and a handmade diffuser—the biggest investment is a few hours of your time

The main part of the ringflash diffuser is made of two plastic bowls or containers—one large, but not too deep, and the other smaller in diameter but around the same depth. For the larger bowl a plastic microwave plate cover or transparent plant holder (used here) is ideal.

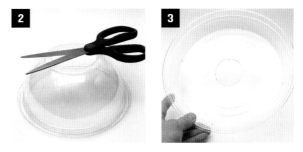

The first task is to cut the bottom out of the smaller bowl, leaving a narrow rim around the base. Depending on the type of plastic the container is made from, you might need a sharp pair of scissors, a craft knife, or a rotary tool.

Place the small container in the center of the larger one and, using a marker pen, mark the inside edge of the hole you have just cut, and cut out a matching hole in the center of the larger bowl. This is where your camera's lens will be when you use the flash.

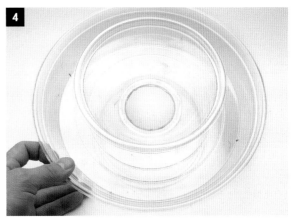

Align the holes you have cut in the bottoms of the two bowls and glue them together. Epoxy resin is the best glue for this task as it produces a very strong bond. For the best adhesion, roughen the areas you are going to glue using sandpaper, or lightly scratch the plastic with the edge of your scissors or craft knife. Give the glue plenty of time to dry before moving on.

Now, cut a slot in the side of the larger bowl. This should be slightly larger than the head of your chosen flash so you can add a card "flash mount."

#31

6 At this point you can paint the bowls flat black. This is optional, but recommended as it will make the finished diffuser look more professional and reduce any reflections that could cause lens flare.

7 To help support your flash, make a three-sided holder from thick cardstock, as shown. This should be the same width and depth as your flash, with flaps at the top of the holder to fit through the hole in the side of the large dish. Fold the flaps over so they are on the inside of the large bowl and glue or tape them into place.

8 Next, cover the area between the two bowls with aluminum foil. If you crush the foil, then flatten it out again, this will help reflect the light around the inside of the diffuser. Use glue and tape to secure the foil, and make sure you don't cover up the flash mounting hole.

9 To create an even spread, you need to add some diffusion material. Parchment/wax paper, or tracing paper are both good materials for this. Draw a circle that matches the diameter of the outer bowl, then a second circle inside that matches the size of the smaller bowl. For additional diffusion, you can use two diffusion rings.

10 Cut around the larger circle, remove the center disc, and use short pieces of clear tape to hold the circular diffusion ring in place.

11 To attach your flash to the ring adaptor, slide it into the card flash mount and secure it with a rubber band or tape. Now all you need to do is point your camera through the hole in the center of the ring adaptor and start shooting with the ringflash look!

RIGHT As well as being popular with fashion photographers, ringflash is perfect for creating even lighting in macro and close-up shots, such as this high-key photograph of a seashell.

#32 PORTABLE BEAUTY DISH

A beauty dish is one of the most commonly used light modifiers in portrait and fashion photography. The dish creates a circular, even light that produces soft shadows that gradually become darker. This is achieved by firing the flash directly at a small plate (usually silver) held a few inches in front of it. The light reflects off the plate, back into a larger dish, which bounces it back out to illuminate the subject. The light is diffused each time it get reflected, so the beauty dish's "double bounce" method is a great way of creating a larger spread of light using a very compact reflector.

Most commonly, a beauty dish is positioned above head height, quite close to a subject and at a 45-degree angle from their face. This adds definition to facial features, particularly cheek and jaw bones, but without introducing hard shadows. It's typical for a large reflector (see Project 24) to be placed below the subject to bounce light back up from the beauty dish to soften the shadows even more. Despite the soft shadows, the light itself is still direct, and can be quite hard, particularly if the dish is made of a silver reflective material. This adds definition and reveals fine detail, but can be unflattering if the subject has less-than-perfect skin—when a beauty dish is used for fashion photography it is used on models with immaculate skin, or at least a lot of make-up or post-production editing.

As with most studio flash equipment, a beauty dish can be expensive to buy—especially if you need to buy a studio strobe to go with it—but it is possible to make one for your portable flash using items that can be purchased for very little in most homeware stores.

<div style="border:1px solid #999;padding:4px;">

DIFFICULTY ★ ★

</div>

WHAT YOU NEED

- Portable flash
- Large, clear plastic dish or bowl
- Small, clear plastic dish or bowl
- Scissors
- Craft knife
- Double-sided tape
- Black tape
- Sharpie or marker pen
- Zip ties, string, or wire
- Aluminum foil
- White spray paint
- Black spray paint
- Drill or rotary tool

LEFT Positioned above head height and quite close to the subject, a beauty dish can create well-defined features.

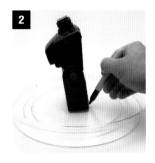

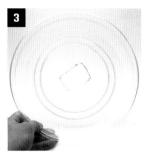

Like the ringflash adaptor in the previous project, the main ingredients of the beauty dish are two plastic bowls—a small one that you will fire your flash into to start with, and a larger one that will act as the main reflector.

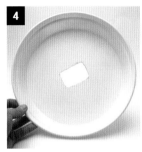

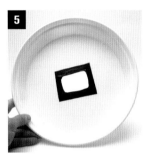

Start by holding your flash in the center of the large bowl and drawing around the head to mark it on the bowl.

You will need to cut out the shape you have just marked to allow the flash head to fit through. Depending on the type of plastic the bowl is made from you may have to use scissors, a craft knife, or possibly even a rotary tool to do this.

Once you've cut the hole, use flat white spray paint to paint the inside of the bowl. This will help diffuse and soften the light.

When the paint is dry, stick strips of black tape around the hole you have cut to stop any sharp edges from scratching your flash when it is slid into place.

Take the smaller bowl and mark and cut around its circumference to reduce its height, to around 1¹/₂ inches (4cm). If your bowl is already quite shallow you can skip this stage.

#32

7 Crumple some aluminum foil and use glue or double-sided tape to stick it to the inside of the smaller bowl. Try to keep it as crumpled as possible, as this will help to reflect the light in different directions. If you want to, spray the outside of the smaller bowl black to make it neater.

8 Next, mark three points on the small bowl at around the 12, 4, and 8 o'clock positions. Use a drill or rotary tool to make a small hole at each of these points, then drill holes in identical positions in the larger bowl.

9 Position the smaller dish inside the larger one, with the aluminum-coated surface (the inside of the small bowl) facing the white interior of the larger bowl. Align the holes you drilled and thread wire or string through them so the smaller one is suspended in the middle of the larger bowl, directly over the hole that has been cut for the flash. Tie a knot in the string, or twist the wire so the small bowl is held in place.

10 Finally, slide your flash through the hole at the back of the larger dish, using tape to hold the lightweight dish in place. When the flash is fired the light will hit the aluminum foil on the smaller dish, reflect into the larger bowl, and bounce off the white surface to produce a light that's perfect for portraits.

TIPS

By changing the type, or color of spray paint you use in the large dish you can vary the light your beauty dish will produce. Using silver or even a mirror finish spray paint instead of white will make the light harder, and add more contrast to your shots. Using a gold dish produces a similar level of contrast to silver, but the golden light will add a bronzed look to skintones.

You can also experiment with bowls of different depths and diameters—a wider dish will produce softer light. Alternatively, stick a sheet of parchment/wax paper or tracing paper to the front of the beauty dish to soften the light even more.

RIGHT A beauty dish can be unflattering if your model has less-than-perfect skin, so consider makeup and image-editing as essential parts of the process.

#33 LOCATION LIGHT TENT

Photographing close-up subjects outdoors is never easy. For a start, you will often find yourself dealing with a shallow depth of field, even with the smallest aperture setting on your lens. This can be overcome using focus stacking techniques (see Project 12), but this won't help with another common problem: harsh, contrasty lighting. This can prove especially problematic with delicate subjects such as flowers, where a softer light would be preferable. To a certain extent reflectors can be positioned to bounce the ambient light and lighten shadows, but it can be awkward to use more than one reflector and operate your camera at the same time. However, as you will see in this project, there is a simple solution: a portable location light tent. It can also come in handy for studio shots as well!

DIFFICULTY ★ ★

WHAT YOU NEED

- 5 × 20 inches/50cm lengths of plastic pipe (3/4–1 inch/ 20–25mm diameter)
- 4 × 10 inches/25cm lengths of plastic pipe (3/4–1 inch/ 20–25mm diameter)
- 2 × T-connectors for pipe
- 4 × right-angle connectors for pipe
- Electrical tape
- White cotton fabric (or similar) for diffuser

TIP

It's a good idea to tape around the slit you cut in the front diffuser panel. Use electrical tape on both sides of the diffusion material to prevent it from splitting further.

NOTE

If you want your frame to be more rigid once it has been assembled, tape the joints after step 3. Doing this will hopefully stop the legs from rotating inside the connectors.

LEFT On a bright day, direct sunlight can create harsh shadows. A light tent can quickly overcome this, diffusing the light to illuminate your subject more evenly.

1 For this project, taping the joints with electrical tape is preferable to gluing them, as it will enable you to dismantle the light tent when you're finished. Start by taking one of your 20 inch/50cm lengths of pipe and attaching a T-connector to each end as shown in the accompanying illustration.

2 Fit a 10 inch/25cm length of pipe to each end of the T-connectors to create an "H" shape, and then attach a right-angle joint to the end of each of the shorter pipes, making sure to point the connector downward.

3 Fit your final four 20 inches/50cm lengths of pipe to the downward-pointing connectors to create legs for your light tent frame, which will now be fully self-supporting.

4 To make the diffusion material for your frame, measure the top, sides, and back of the frame and cut pieces from your shower curtain to match these dimensions. Use small squares of adhesive hook and loop fastener to attach the diffusion material to the frame—a small square in each corner of the diffuser panels should suffice.

5 For the front diffusion panel, cut a piece of shower curtain to match the dimensions of the frame, but cut a slit in the center that will allow you to poke your camera lens through.

USING YOUR LIGHT TENT

To use your light tent, simply place it over your subject and attach as many (or few) of the diffusion panels as you want. Remember that as well as acting as a diffuser to soften harsh lighting, the panels will also reflect light, so can be used on either side of your subject. They can be employed to create a seamless white background for outdoor subjects, or to act as a windbreak, to prevent a breeze from creating subject movement.

#34 LIGHT TABLE

A lightbox can be a really useful bit of equipment. Not only does it make checking negatives and viewing slides really easy, but it can also be helpful while mounting and finishing print work, or even shooting, as seen in Project 9. Unfortunately, a large photographic lightbox takes up a lot of space and can be expensive. However, if both space and money are tight, why not build yourself a lightbox coffee table? For this project I used a low-cost "Lack" coffee table from Ikea. Other tables may also be suitable, but you might need to modify the construction process slightly.

WHAT YOU NEED

- Side table
- 0.3-inch/8mm thick clear acrylic sheet (19 × 19 inches/480 × 480mm)
- 0.1-inch/3mm thick translucent acrylic sheet (19.5 × 19.5 inches/ 500 × 500mm)
- 16-foot/5-meter roll of self-adhesive white LED strip lighting (with power adapter)
- 4 screws (minimum length 1¼ inch/30mm)
- Drill
- Knife
- Chisel
- File or sanding block
- White paint

Carefully mark out a square on the tabletop measuring 19 × 19 inches/480 × 480mm. Double check your measurements, then carefully cut along the lines using a knife and a nonslip metal ruler: it may take quite a few cuts to break through the table's surface.

Remove the honeycomb support inside the table and check your clear acrylic fits the hole you have made. You can widen the aperture with a sanding block if necessary.

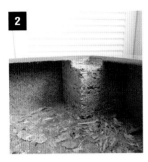

2 The "Lack" table has four chipboard corner reinforcements, which will have been partially exposed when you removed the tabletop. These will form the mounting points for the clear acrylic. Chisel or cut each corner down until your 0.3 inch/8mm thick acrylic sits flush with the tabletop when inserted into the aperture. Paint the interior of the table with white gloss paint or some emulsion.

3 Drill a small hole in the underside of the table for the power adapter cable and lay out your LED strip lighting. The power adapter should have a small audio style connector that will allow you to disconnect the cable from the table when not in use.

4 Drill a hole in each corner of both of your sheets of acrylic. To mark out the position of the holes, install the sheet of clear acrylic and drill directly through it into the corner mounting points. Ensure the holes are large enough for your screws otherwise the acrylic can crack. Use these holes to mark the translucent acrylic and drill that as well.

At this point you should round off the edges and corners of the translucent acrylic with a file or a sanding block.

5 The final step is to assemble the parts. Thoroughly clean both sheets of acrylic, sandwich them together, and then screw them to the table. I chose to use round-headed screws, but you could use screw caps for a smoother look.

#35 STUDIO SOFTBOX

Softboxes form the backbone of most pro photographers' studio lighting kits, whether they are used for shooting portraits, still-life setups, or simple product shots. The beauty of a softbox is its ability to produce a large, diffuse spread of light that can be used for overall illumination and built on with other lights, such as the grids and ringflash we have covered elsewhere. This project shows you how to build your own softbox with a quick and easy way to mount a portable flash unit. Unlike the previous projects, the softbox uses a wood frame, but don't let this put you off—you don't need advanced carpentry skills to put it together. All the materials you need should be readily available at your local hardware store for only a fraction of the price you'd pay for a pro softbox—and the results are not that different!

DIFFICULTY ★ ★ ★

WHAT YOU NEED

- Portable flash (off-camera)
- Wood for frame and flash cradle (approximately 15 feet/5m, measuring around ¾ × ½ inch/19 × 10mm)
- Wood for support (approximately 3 feet/1m of thicker wood strip measuring 1½ × ¾ inches/38 × 19mm)
- Small L brackets (interior and flat brackets)
- Small screws (for L brackets)
- Small picture hangers
- Approximately 12 feet/4m thick wire
- 4 large sheets of cardstock
- Aluminum foil
- Aluminum tape
- Duct tape
- Bolt or nut (for mounting the softbox)
- White cotton fabric (or similar) for diffuser
- Velcro
- Screwdriver
- Drill
- Saw
- Pliers
- Spray glue
- Staple gun

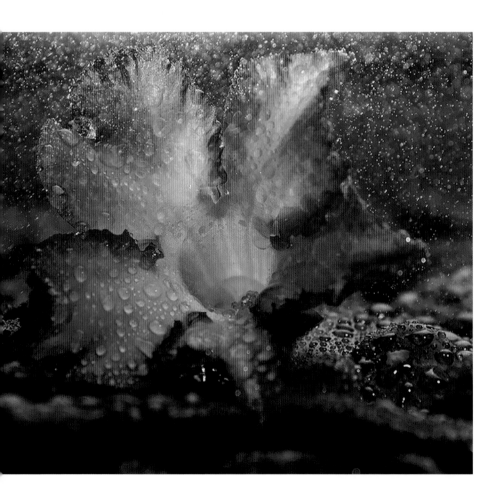

LEFT This flower was lit from behind with a homemade studio softbox, with two additional flashes adding the modeling.

1 This project is to make a softbox measuring 40 × 24 inches (100 × 60cm), which is a good size for portraits and more than adequate for still-life setups. The front frame is a simple rectangle made from thin wood strips measuring around ¾ × ½ inch (19 × 10mm).

With the size of the softbox decided, cut out the lengths you need from the wood and use small L brackets to join the ends together, making a flat frame. Because the wood is quite thin it's a good idea to drill pilot holes to stop the wood from splitting.

2 Next, build a frame to hold your flash. There's no single way of doing this, but I decided to go with a cradle design so the flash can be easily removed. Mark out a few small sections of wood to build this, the key measurements being the width and depth of the flash. To join the sections together I used inside L brackets. There's no real science to this; just build the cradle a section at a time, holding the flash in place as you position each piece.

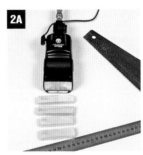

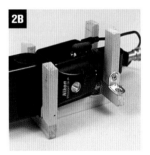

3 The cradle now needs to be attached to the front frame. A frame-to-flash distance of roughly 20 inches (50cm) works well for a softbox of this size—larger softboxes will require a greater distance, while smaller softboxes will work with a shorter distance between the flash and the frame. To make it easier to join the cradle to the frame (and keep the two parts the correct height and distance apart) I made a temporary stand for the cradle from two 20-inch (50cm) lengths of wood joined with an inner L bracket.

TOP This model Jaguar might have fooled you for the real thing. See the setup at the end of the project, on page 113.

#35

4 I used 20-gauge fencing wire and small picture hangers to attach the two parts together, but any strong wire that you can bend by hand (but doesn't flex on its own) will work. Start by cutting four 40-inch (100cm) lengths of wire and roughly straighten them out. Feed one end through a picture hanger and fold the wire back on itself so it's held in place. Then, screw the hanger to the front frame (drilling a pilot hole first). Repeat this on all four corners, and then attach the other end of the wire to the flash cradle in the same way.

Trim the excess wire off each end and remove your temporary support. Don't worry if it all seems a bit wobbly at this point, the next step is to add a brace that will also act as the mounting point for the whole softbox.

5 The brace is a length of wood that fits diagonally between the bottom of the frame and the camera cradle. Cut a length of wood that's a few inches longer than the gap between the cradle and frame and, with the softbox placed face down, hold the support brace in place and draw the join angle onto the edge of the wood—this will make sure the brace fits neatly.

Saw the ends at this angle and attach the brace using inner L brackets. Bend the brackets at a right angle using two pairs of pliers and screw the brace in place (after drilling pilot holes!).

6 The next task is to add a mounting bracket for a bolt that will attach the softbox to a lightstand. Use a slightly thicker piece of wood than used for the brace and draw a line on it that would be roughly parallel to the floor when mounted on the brace—it doesn't have to be totally accurate, but try to get the angle as close as you can.

Saw along this line, then determine the balance point of the softbox. This is the point where you can sit the brace in your hand and the softbox doesn't want to tip forward or back. Screw the mounting bracket to the brace at this point and your softbox "skeleton" is complete.

A simple studio still-life often needs nothing more than a single softbox to produce fantastic results.

7 Now it's time to add the softbox "skin," and the best material for this is thin cardstock. It's a good idea to number each side of the softbox at this point, so you can match your cardstock to the side.

To create your skins, lay the softbox on its side, on top of the cardstock, and trace the outline of the softbox so you have a triangular shape. Remove the softbox and expand your line by a couple of inches, so you have extra material to fold over and stick. Label the panel so you know which side it attaches to.

Repeat this process for each side of the softbox and cut out each of the panels.

8 Before you can attach your panels, you need to cover them with aluminum foil so they reflect as much light as possible and make the softbox light-tight. Cut lengths of foil large enough to cover the panel and stick them on with spray glue, with the shiny side showing. Spray the glue on the cardstock rather than the foil, and use a cloth to rub the foil over—this will smooth out any air bubbles and make sure the cardstock and glue are bonded. Trim off the excess foil, and repeat the process for the rest of your panels.

9 Now you can attach the panels to the frame. Start with one of the larger side panels, and use a small piece of aluminum tape on the inside of the panel to attach it to the camera cradle and the wire. Use the extra material at the cradle end of the panel to create a tab and staple it to the wood. Then, tape the wide end of the panel to the softbox wire to hold it in place.

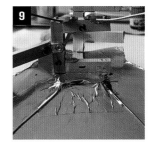

10 Next, cut two lengths of aluminum tape the same length as the wires. Run this over the top of the wires to hold the panel in place on both sides. Tape beyond the edge of the panel so you are left with a long tape flap that you can attach the adjacent panel to. Finish up by stapling the panel to the front wood frame.

11 Repeat the previous step with the other side panel so you have both sides in place, with tape flaps running the length of the four wires.

12 Next, add the panel to the top of the softbox (the side without the brace). Start by stapling the front edge to the frame, making sure it is lined up properly. Then, turn the softbox upside down so the panel is flat on your work surface, and attach it to the side panels using the tape flaps.

Once that's done, trim off any excess cardstock on the outside of the panel, and strengthen the edges with duct tape.

13 Before adding the last panel, you need to add the lightstand mount. Lightstands vary, so if your lightstand doesn't have a "drop in" style mount (or you want to mount the softbox on a regular tripod) you might need to make a small hole to wedge/glue a nut into. I've fitted a bolt, with two nuts attached so the lightstand has something solid to clamp onto.

14 It's time to fit the last panel, but because of the brace, you will need to trim the panel to size before fitting it. Repeat the procedure outlined in steps 12 and 13, stapling the front edge of the panel to the frame, taping up the inside with aluminum tape, then strengthening the outside edges with duct tape.

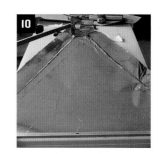
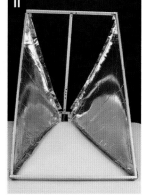
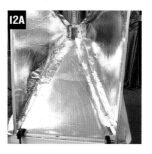
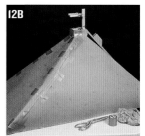

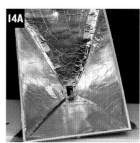

15 The final stage is to add the diffuser panel to the front of the softbox, and a piece of white cotton fabric is perfect. Lay the softbox face-down on the fabric, trace around the outer edge, and add an inch all around so you have got material to fold around the frame.

16 The best way of attaching the diffuser is with Velcro, so you can remove the diffuser to wash it, replace it, or make any repairs to the inside of the softbox. A few short tabs are all that's needed, and you can add an extra tab to the corners to keep them neat.

17 And that's it—one large softbox for your portable flash. All you need to do is set it up on a lightstand or tripod and start shooting!

15A

15B

16A

16B

TIP

Your softbox doesn't have to match these dimensions— you can make it larger or smaller, or change the shape to a narrower rectangle, or a square. The important thing when you change the size is the flash-to-diffuser distance—if your flash is too close it won't light the diffusion panel evenly. To avoid this, make your softbox deeper, so the flash is further from the diffuser.

LEFT Two homemade softboxes were used to light this model car, with an additional two flashes fired through plain paper that acted as a diffuser and a reflector. For the final shot, see page 109.

#36 SNOOT

Most portable flash units are designed to throw out a fairly wide spread of light, to cover the scene you are photographing. However, there will be occasions when you want to focus the light down to a much narrower spot—to highlight a particular area, create a spotlight effect on a background, or prevent light from falling on a background if you're taking a portrait. Professional photographers using studio strobes will achieve this using a reflector known as a "snoot," which is a type of reflector dish (usually a tube or cone) that fits to the front of the flash to physically restrict the beam of light from the flash to a smaller area. This is something you can easily make for your portable flash units as well, giving you studio-style control over your lighting.

DIFFICULTY ★

WHAT YOU NEED
- Portable flash
- Cardboard
- Craft knife
- Ruler
- Glue
- Black duct tape (optional)

Length of Snoot

Flash Head Height | Flash Head Width | Flash Head Height | Flash Head Width

TAB

LEFT A flash fitted with a snoot and positioned behind a sheet of colored plexiglass can be used to create a spotlight effect on a background.

ABOVE The directional control of a snoot lets you concentrate light onto a very specific area of the image, as in this atmospheric portrait.

1 The starting point for a snoot is a sheet of cardboard—the cardboard from a cereal box is ideal. Measure the width and height of your flash head, and transfer these measurements using the template shown left as a guide. Essentially, you are making a rectangular box that's open at both ends.

The length of your snoot will determine how small the pool of light from the flash will be; the longer the snoot, the smaller the pool of light. I'm making a snoot that's 6 inches (15cm) long, but note that, whatever length you want, you need to add an extra inch (2.5cm) to slide it onto the flash.

2 Cut out your template and use a ruler and the back of a craft knife to score the fold lines, not forgetting to fold the tab along the longer edge.

3 Apply glue to the tab and stick your snoot together. If you're using a cereal box, fold it so the printed side is outward, otherwise the print could introduce a color cast to your flash.

4 Once the glue is dry, wrap the snoot in duct tape to make it neater and stronger, if you wish.

5 All you need to do now, is slide the snoot onto your flash head and use a small piece of tape to hold it in place. When the flash fires, your snoot will funnel the light to create a narrow beam, or "spotlight" effect.

#37 STUDIO STRIPLIGHT

Here is an easy way to make a studio striplight—the sort of light that usually houses a long, daylight-balanced fluorescent tube. However, here we'll use nothing more than your portable flash to create the distinctive striplight effect.

The main ingredient is a long, thin cardboard box. You might be able to find one that's a suitable size, or you could make one. There are no exact dimensions to follow, although a box that's around 2–3 inches (5–7.5cm) in depth, 6–8 inches (15–20cm) wide, and roughly 3–4 feet (90–120cm) long will work well. The one used here was a "found" box that originally contained a clothes rack. It has the added benefit of flaps at the front, and while these are optional they are very useful for controlling the light.

DIFFICULTY ☆

WHAT YOU NEED

- Portable flash (off-camera)
- Long, thin cardboard box (made or "found")
- Duct tape
- Aluminum foil
- Marker pen
- Spray glue
- Scissors
- Craft knife
- White cotton fabric (or similar) for diffuser

BELOW A single striplight in front of the models and below the camera was used for this portrait shot.

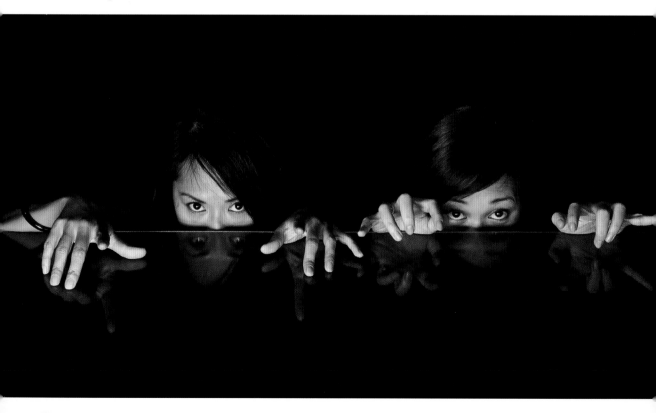

The first step is to strengthen all of the joins and corners of the box with duct tape.

Once the box is strengthened you need to line it with reflective aluminum foil. The best way to do this is to roll out the foil (shiny side down) and draw around the base, sides, and top/bottom of the box. Carefully cut the pieces out of the foil and use spray glue to stick them on each side of the inside box panels with the shiny side of the foil showing.

With the box lined, trace the outline of your flash on one end. Use a craft knife to cut just inside the outline, so your flash is a reasonably tight fit and friction alone will hold it in place.

The next step is to add a diffuser to the front of the box. I'm using cheap, thin white cotton fabric, but you could also use double-thickness parchment/wax paper or tracing paper. Place the box face down on the material and trace the outline. Add 1 inch (2.5cm) around the edges so you have extra material to fold over and stick to the box.

ABOVE & RIGHT A simple still-life shot, lit using a single striplight and two reflectors.

#37

5 Cut out the front diffuser, and stick it to the box using tape, glue, or both. I stretched my fabric tight and glued the material to the flaps on either side of the box, holding it in place with clips while the glue dried. I then folded the edges over and taped them all the way around.

6 That's it, one striplight softbox for your portable flash! You can now push your flash in the hole at the top and start shooting. The design can be used without a stand—either on its side, or upright—and if it doesn't balance very well with the flash in place try adding a couple of cardboard feet to support it. Alternatively, add a hole at the bottom and/or one side and use a large, flat washer and a nut to mount it on a tripod or light stand.

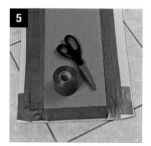

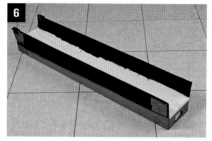

TIP

Having flaps on the front of your striplight lets you modify the light, from a reasonably wide beam, to a narrow slit.

Flaps open

Flaps closed

LEFT & RIGHT For this striking picture (right), two strip lights and two bare flashes were used to build up the lighting (left).

#38 LED RINGLIGHT

Most photographers will have seen shots taken using a ringflash, whether it's in the context of high-end fashion and portraiture, or the macro world of insects and flowers. Until recently ringflash has largely been the preserve of professional photographers and monied enthusiasts, as even the most modest battery powered unit can be fairly expensive. However, recent developments in lighting (and the inclusion of HD video modes in most cameras) has meant that the manufacturers have turned their gaze toward continuous light sources, most notably, LEDs.

As a result, there is now a wide range of LED lights available, which includes an array of continuous ringlights. Yet although they are generally cheaper than their flash counterparts, LED ringlights still command a relatively premium price, especially when you consider their often basic configuration. However, as you will see in this project, making your own high-power custom ringlight isn't expensive, and it's not overly complicated either—as long as you employ a bit of common sense!

DIFFICULTY ★ ★ ★

WHAT YOU NEED

- Circular LED camping light
- 4 × AA battery box with on/off switch
- Filter holder (see Tips)
- Dremel or rotary tool with cut-off wheel and sanding drum
- Glue gun or epoxy resin
- Electrical tape

TIPS

Use a filter adapter ring that matches your largest diameter lens: for smaller lenses you can add step-up (or step-down) rings to the adapter to mount it to your camera.

The physical depth of the ringlight may cause vignetting with wide-angle lenses, as the edges of the light literally creep into frame, so it's best to use the light with longer focal lengths.

LED's may create a slightly blue color cast, so be prepared to set a custom white balance, or shoot Raw and correct the color later.

LEFT The LED ringlight is great for macro photography and close-up portraits, and will provide a telltale "donut" in your subject's eyes.

The start point here is a circular LED camping light, which can be found online or in most camping stores. Look for one that has a hole in the center, and plenty of LEDs around the edge: the light I'm using here contains 48 LEDs in two rings around the outside of the large plastic shell. Perfect!

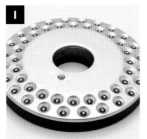

The first thing you need to do is junk the on/off switch. Before you do, look at the wiring: getting rid of the built-in switch, means you'll need to rewire the lamp later on. You need to identify which wires lead to the positive battery terminal(s) and which lead to the negative terminal(s). Each ring of LEDs has two "tracks"—the inner track carries the positive current, and the outer track carries the negative current. So that I remember this, I've marked the negative wires with marker pen before cutting them as close to the on/off switch or battery terminal as possible.

Remove the on/off switch assembly and the metal battery terminals: you're not going to use them, and they'll only get in the way at the next stage. I've also removed a couple of additional positive wires, so I'm left with just one negative and one positive wire for each ring of LEDs.

Now the fun part begins. Take your filter ring and place it centrally on the outside of the LED lamp's front cover. You don't have to be precise, but it should be relatively easy to get it close to central. Then, draw around the inside of the filter ring. Repeat the process on the back casing.

#38

5 Reach for your Dremel (or similar cutting tool) and cut out both of the circles you have drawn. If you don't have a Dremel, another option would be to use a drill with a 1/4–1/2 inch (60–125mm) drill bit and drill lots of holes around your circle to get off as much material as possible. Then you can try using a small hobby saw or other cut-off tool to complete cutting the rough outline. Regardless of the tool you use, once the holes are made use a small sanding drum attachment on your Dremel (or some sandpaper) to tidy up the edges. Don't go too crazy with the sanding though, or you might take away too much of the plastic.

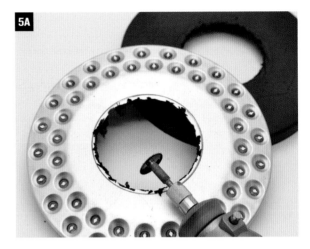

6 Once your holes are cut and tidied, take your filter holder adapter and glue it to the back cover of your LED light, making sure it is as central as possible. A hot glue gun or epoxy resin will do the job here.

7 You're now ready to wire up your light, but before you do, you need to make a hole for your wires to pass through. Roughly assemble the ringlight and attach it to a lens. Mark a point somewhere toward the top of the ring and drill a hole through the back of the ringlight as illustrated.

8 Next, take your battery pack and connect the integral wires to the positive and negative wires you marked earlier. Remember, the red wire is positive and black is negative.

The easiest connection method is to twist the wires together (first the internal wires, and then the wires running to the battery pack) and hold the join together with electrical tape. As the light will be running off a 6-volt current, this is more than adequate.

Once the wires are connected, close the ringlight and switch the battery pack on to check that your LEDs work: providing you marked your wires correctly it should.

9 To finish up, you need some way of keeping the battery pack close to the light. One option is to use a belt clip from a tape measure to attach it to the camera strap (or your belt if you extend the connecting wires), but I'm using the foot from a redundant flash. You often find low-cost flashes in yard sales and online, and as you aren't going to use it, it doesn't have to be operational. All that's left is to slide the battery pack into the camera hotshoe and mount the ringlight.

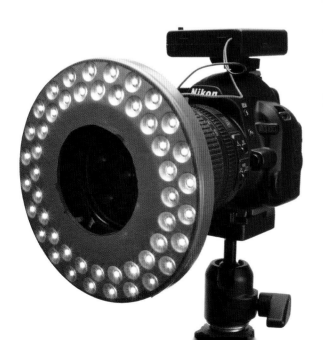

#39 JUMBO DIFFUSER

Of all the possible light sources you can use for photography, the cheapest—and, arguably, easiest to use—is sunlight, or at the very least "daylight" if the sun is hidden behind cloud. With the right tools it's possible to create a virtual studio outdoors, using natural light to illuminate your subject. The key tools are reflectors (sheets of white, silver, and/or gold card are ideal), but on especially bright days a diffuser can be equally beneficial, enabling you to soften the light falling onto your subject and avoid deep, hard shadows. Although diffusers are available commercially, in this project you'll see just how easy it is to construct a lightweight, portable diffuser that can double as a reflector. All sizes can be modified depending on your requirements.

DIFFICULTY ★ ★

WHAT YOU NEED

- 3/4-inch–1-inch (20–25mm) diameter plastic (PVC) pipe
- 4 × right-angle corners for pipe
- 2 × T-pieces for pipe
- Translucent white shower curtain
- Saw or similar cutting tool
- Electrical tape
- Glue for pipe (optional)
- Velcro

TIP

If you find your frame flexes more than you would like, use additional supports and cross pieces for added rigidity.

The maximum size of your diffuser will be dictated by the size of the shower curtain you are using: the curtain I'm using here measures 70 × 70 inches (180 × 180cm), so that would be my maximum possible diffuser size. However, as the pipe I've chosen comes in 12-inch (300cm) lengths, I've decided to make my diffuser rectangular and slightly smaller (roughly 60 × 40 inches/150 × 100cm) so I'll only need to use two pipes. The basic design is shown in the accompanying schematic (1).

RIGHT-ANGLE CURVE

30 inches/75cm

T-PIECE

40 inches/100cm

PIPE

1

2 With a rough plan in mind, the first step is to cut the pipe to size. My diffuser calls for three 40 inches/100cm lengths, plus four 30 inches/75cm lengths. A hand saw is more than capable of cutting through the pipe, but you may need to sand or file any rough edges. Alternatively, you can use dedicated plastic pipe cutters, although they are more expensive.

3 With your pipe cut to size, assemble the frame using the right-angle corner pieces and T-pieces. You can glue the joints if you want to construct a permanent frame, or tape them so you can dismantle the diffuser between shoots. A compromise is to glue the corners and T-pieces to create two long, permanent sides, and then tape the cross pieces so your diffuser will pack down for transporting, but require minimal assembly and disassembly.

4 When you've made your frame you need to attach your diffusion material. I'm using adhesive Velcro fastener material for this, sticking a tab to each of the corners of the frame, as well as the top of the T-pieces. This will be adequate for calm conditions, but may pull free in a breeze, so you might want to use longer strips along your pipes as well.

5 Peel the backing paper off your hook and loop fasteners and lay your shower curtain over the top of your frame. It doesn't have to be stretched tight, but you don't want it to sag either. Press down to stick the diffuser to the Velcro.

6 If necessary, trim your diffusion material to size and you're good to go. To use the diffuser, simply have an assistant hold it between your subject and the sun to minimize the intensity of the shadows, and/or close to your subject when you want to use it as a reflector. When you're finished, you can remove the diffuser material and collapse your frame.

#40 PORTABLE GRID SPOT

A useful, and incredibly simple lighting tool is a grid, a device that looks like a honeycomb and is positioned in front of a light. This grid pattern narrows the path of the light to create a concentrated, spotlight effect—a bit like a snoot, but in a far more compact device. Making a grid for your portable flash is easy and, because of its small size, it's perfect for carrying in your camera bag so you can convert your standard flash into a more directional light source.

DIFFICULTY ★

WHAT YOU NEED

- Portable flash
- Snoot (see Project 36)
- Black drinking straws
- Ruler
- Scissors
- Tape
- Glue

TIPS

The longer you have the lengths of the straws in your grid, the narrower the spotlight effect will be.

Your grid can be used in lots of ways, from putting a bright spot of light onto a background, to preventing light from spilling onto a background. Alternatively, use it to accentuate or add highlights to a portrait or even light an entire scene if you have multiple flash units.

Although the grid is similar to a snoot, the straws focus the light much better, so you can produce a similar effect with a more compact device.

LEFT In this image the flower and vase have been lit using a softbox (see Project 35). To add depth, a grid spot has been placed to the left of the vase and aimed at the background to create a brighter spot directly behind the flower.

The starting point for your grid spot is a basic, 3-inch-long (7.5cm) snoot, so follow steps 1–4 of Project 36 so you've got a black snoot to transform into a portable grid spot attachment.

To convert the snoot into a grid, you need to fill the center of the snoot with straws, which will act as guides to focus the light. You need to leave about 1 inch (2.5cm) of the snoot to slide over your flash, so cut your straws down so you have a bundle of 2-inch (5cm) lengths.

Starting at one end of the snoot, align your straws with one open end and start sticking them inside the box. A handy timesaving tip is to tape 6–8 straws into a bundle, then glue the bundles in place, using individual straws to fill the gaps—it's quicker than gluing the straws in one at a time! Keep gluing until you fill the box, and that's your finished grid spot.

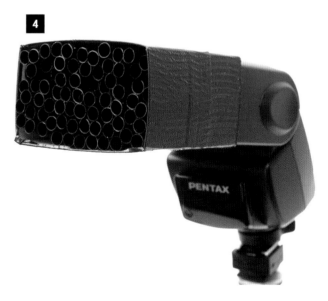

Slide your new grid spot attachment onto your flash, using a small strip of tape to hold it in place. Now, when you fire your flash the light will be directed through the straws, creating a narrow beam of light that's perfect for highlighting small areas in an image.

4
PROCESSING

As we have seen, there are lots of ways that you can start making photographs that are more creative, but there are some things that just can't be done in-camera or by making your own lens and flash accessories. So, to round off our fifty-two projects, this chapter will show you twelve ways that you can transform your pictures on your computer, whether it's re-creating the look of vintage processesor films, or creating truly unique works of art using your home printer.

Most of these projects are demonstrated using Adobe Photoshop, but this doesn't mean that's the only program you can use. Many of the projects can be accomplished just as easily using Lightroom, Affinity Photo, or Luminar. The only thing to note is that the Photoshop tools might be called something different in other programs. Alternatively, if you want to follow these projects using Photoshop, you can download a free, thirty-day trial of the latest version from www.adobe.com.

#41 DIGITAL POLAROID SX-70

When Polaroid abandoned production of its instant films, a range of unique materials and techniques were lost, from emulsion lifts to emulsion transfers. However, prior to this, another unique emulsion was sidelined—SX-70 (or Time Zero) film.

If you're unfamiliar with this particular film, it was designed for the "instant" camera of the same name, which became something of a cult classic. What made it unique—and exciting to creative photographers—was the way in which the film was made. The emulsion was sandwiched between the Polaroid backing and a clear plastic cover, and because the emulsion took a short while to harden, there was a window of opportunity where the emerging image could be physically manipulated and pushed around to create impressionistic, painterly images. However, while the film is no longer produced, it is still possible to achieve a similar effect using your editing program.

DIFFICULTY ★

WHAT YOU NEED
- Image-editing program with Smudge tool (e.g. Photoshop or similar)

TIPS
To emulate the "plastic" feel of a genuine Polaroid, use a high-gloss paper for images made using this technique. To take it a step further you could also add a Polaroid-esque frame made out of thin, matte white paper.

LEFT Original image

Strength 100%

Strength 25%

SMUDGE TOOL
The key to re-creating the manipulated Polaroid look lies with the Smudge tool, which hides in Photoshop's toolbar alongside the Blur and Sharpen tools. While it might not have the most appealing name, it is perfect for re-creating the look of a manipulated Polaroid. Basically, the smudge tool works like a paintbrush, so you can set different brush sizes and change the hardness of the edges. However, instead of applying color to your image, the Smudge tool "smears" the information that's already there—exactly like pushing the emulsion around on Time Zero film. By changing the "strength" of the Smudge tool you can alter its effect, so it has a lesser or greater impact on your image.

DIFFERENT STROKES

With your image open and the Smudge tool selected, it's time to re-create the look of manipulated Time Zero emulsion. Experimentation is the key here, so play around with different brush sizes and vary the hardness of the brush to see what different effects can be achieved. Alter the strength of the smudging as well.

As the smudge tool is used freehand, different effects can be achieved by applying it in different directions. For example, to remove a background quickly, a large brush and high strength combined with a circular smudging action does the job well, whereas "straight" smudges can create a regular, abstract background.

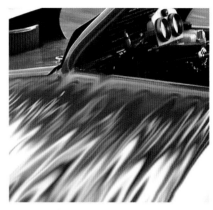

Straight strokes

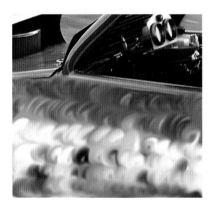

Round strokes

OUTLINES

Depending on how dry the emulsion was, and how hard you pressed, one of the properties of Time Zero film was that black or white lines could be added to the manipulation, creating outlines and fake highlights that didn't exist in the image to start with. The obvious way of replicating this digitally is to use the Pencil or Paintbrush tool to add thin black or white lines that you can blend into the picture using the Smudge tool.

ABOVE Final image. For the ultimate Polaroid finish, make your prints on inkjet transparency film, then mount the film ink-side down onto high-gloss white media. Frame this in matte white paper and you will have a great "Polaroid."

BLACK-AND-WHITE PROCESSING

As digital photography has rocketed in popularity, many people simply don't think of shooting film any more, let alone processing it themselves. Yet images shot on black-and-white film have a very different "feel" to those recorded digitally, and surely photography is all about exploring different creative opportunities? Moreover, processing black-and-white film isn't that hard, as you'll see in this project.

Almost any black-and-white film will do, although you should avoid color films and the black-and-white emulsions designed for the C-41 color process (such as Kodak BW400CN,

Ilford XP2, and Fujifilm Neopan 400CN). It might also be wise to avoid very fast or very slow films if this is your first foray—something within the range ISO 100–400 would be perfect. In this project we'll be processing a 35mm film, although the same basic principles apply to any film format.

BELOW A rose bush taken with Olympus OM1 and Zuiko 35mm f/2.8 lens, Kodak TMax 100 film and HC-110 developer.

DIFFICULTY ✶

WHAT YOU NEED
- Film developing tank
- Darkroom/film changing bag for loading the tank
- Chemicals (Developer and Fixative)
- Clock, watch, or timer
- Thermometer
- Measuring jugs
- Syringe (optional)
- Bottle opener
- Scissors
- Clothes pegs
- Rubber gloves

WARNING
Chemicals should always be used with respect; used in the way they were intended (and as the instructions direct); and should be kept well away from any utensils used in the preparation of food and drink.

Buy measuring jugs for use in photography only and take care at all times: developer is caustic and can be an irritant, so wash it off immediately if it comes into contact with skin. Similarly, fixer carries dissolved silver, which is toxic.

NOTES
A film can be stubborn to load—keep calm, take it out of the spiral, and start again.

Film spirals should be kept clean and dry: dirt or moisture can ruin unprocessed film, or make loading difficult.

WHICH CHEMICALS?

There are many different chemicals available for black-and-white processing, all of them excellent, and many suitable for a beginner. The chemical that "makes" the image is the developer, and this comes in two forms: liquid or powder. Liquid developers are easier to make up and better when working with smaller volumes, and Kodak HC-110, Rollei R09 (formerly Agfa Rodinal), and Ilford Ilfosol-S are particularly recommended. Kodak's D76 and Ilford's ID11 also work well, but are only available as powders.

The other chemical you need is fixer. Its job is to stop the film being affected by light, so the negative will not fade. Any of the so-called "rapid fixers" will be fine.

You might also hear people talk about using a stop bath (to halt the developer), but for this process plain water is all you'll need.

SOMEWHERE DARK

Before you begin, you will need somewhere that is completely dark, where you can load the film into the developing tank. A room that you can black out completely would be ideal, or you might wait until night-time, draw all the curtains, and work in the bedroom with all your equipment underneath the bedsheets—it will work! Alternatively, you can purchase a "changing bag," which is a black, light-tight bag with elasticated holes for your arms, so you can load your film inside the bag.

LOADING THE TANK

Loading your exposed film into the developing tank must be done in total darkness (your darkroom or changing bag) as you will be taking the light-sensitive film out of its light-tight cassette. Any accidental exposure to light and you risk the film fogging.

As you're working in the dark, you will not be able to see what you are doing (obviously!), so you need to learn what everything feels like in the dark. This is actually harder than it might sound, so it's a good idea to practice loading an old roll of film in the light first, and then with your eyes shut, until you're ready to give it a go for real.

1 The first step is to open the film cassette. There are special tools to do the job, but a regular bottle opener works fine.

2 Next, retrieve the film from inside the casette and square it off with scissors. It may help to round the corners with scissors.

3 The spiral of the developing tank is what you load your film onto, and is so-called because the film forms a spiral around the central core. Most spirals are self-loading, which means that once you get the loading started, the rest of the film will load with a twisting action.

Check your tank's instructions carefully, but in most instances you need to locate a groove that the film goes into initially. This is where your practice will pay off—if you can't find the groove, or the film doesn't go in, turn the spiral round and try again.

Once you have located the groove, push the end of your film in, and pull it gently about halfway round the spiral. Then, start the twisting motion, turning your right-hand side forward and backward, until the film is nearly loaded.

4 Remove the film from its cassette by cutting it as close to the end as possible, and make a couple more twists on the spiral to load the film fully.

Finally, put the loaded spiral on the central column of the developing tank, fit the rest of the tank together, put the top on securely, and you can return to the light once again.

#42

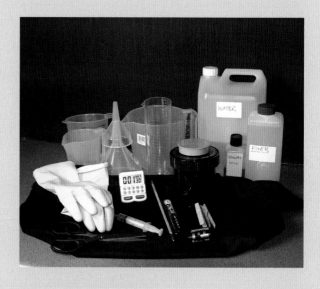

PREPARING THE CHEMICALS

It is important to get all of your chemicals ready before you start. I'm using Kodak HC-110 to develop my film, and have chosen "Dilution B," which means 1 part developer to 31 parts of water (1+31), at the standard developing temperature of 60°F (20°C).

5 My first step is to get a large jug of water ready at 20°C. The instructions on your tank will tell you the minimum amount of liquid you need. My tank states that 300ml is needed to cover a 35mm film, but to keep things simple with my 1+31 mix I decided to make 320ml of developer: 10ml of the developer concentrate and 310ml of 20°C water.

6 When it's mixed, check the temperature again. If it is too hot or too cold you could stand the jug in cold or hot water and stir. A better method is to cool down or heat up a glass bottle by filling it with water, then empty the bottle and pour the developer into it. (Glass is very good at keeping its heat, and the heat in the glass will eventually pass to the developer.) You may have to repeat this process, but ±1/2°C is close enough.

7 Now you can mix the rest of your chemicals. After the developer, you will be using 300ml of plain water (again at 20°C), followed by the fixer. The fixer should be diluted according to the instructions, and should also be about 20°C, although this temperature is slightly less critical. Finally, the rest of the 20°C water will be used for washing at the end, although by this stage the temperature is not so critical—as long as the wash isn't excessively hot or cold it will be ok.

NOTES

Every film-and-developer combination has a specific development time, and this changes depending on the temperature of the chemistry. Therefore, it is not only important to check the recommended development time, but also to keep your temperatures consistent.

A great resource is found at www.digitaltruth.com/devchart.php, which lists thousands of times for different developer/film combinations. Here, a seven-minute development time is recommended for processing Kodak TMax 100 film (rated at ISO 100) in HC-100(B) developer.

This is a good place to start, but with experience you may want to vary your times later.

DEVELOPING THE FILM

The process is now straightforward. You pour the first solution into the tank, wait the right length of time, pour it out, and pour the next one in—that's all there is to it! However, there are a few tips to make it work well.

The most important is agitation. If the chemicals stay in the same place they tend to get used up and become ineffective, which can lead to uneven development or, worse, insufficient fixing. The answer is to stir the chemicals, and your tank may have some method for this: most have a twizzle stick that can be used to gently spin the spiral inside.

A better option is to invert the tank completely (1). This should be a slow, relaxed affair (you don't need to shake the film!) and when you turn the tank upright again give it a light tap on the worksurface to dislodge any air bubbles. The whole operation should take around 5 seconds.

The amount of agitation is also important. I invert continuously for the first minute of development, and then twice every minute thereafter. Some people invert twice every 30 seconds, but whichever option you choose, you should stick with it for all your developing to maintain consistency.

Once the development time ends, pour the developer out (2). Usually, developer is only used once and then discarded.

Then, pour in the plain water that you are using as a stop bath. The water is to dilute and wash any developer off the film, effectively stopping the process. You can use a chemical stop bath that will neutralize the development process chemically. In both instances, this takes about 30 seconds, with continuous agitation.

Pour out the water (or stop bath), pour in the fixer, and invert the tank a few more times. After a couple of minutes in the fixer it is safe to look at your film in subdued light (3). The fixer should remove any white parts of the film and make it transparent, so if the film is not transparent it is not fixed yet. The general rule is to fix for twice the time it takes the film to go completely clear. This could be as little as 2 minutes or as much as 5 minutes or more—some films take longer than others. It is worth saving fixer as it can be used several times—sometimes there is some colored dye from the film that gets into the fixer and "tints" it, but this is not a problem.

Now wash the film in several changes of water. Four changes of water should suffice, provided you do lots of inversions. I recommend 10 inversions for the first wash, 20 for the second, 40 for the third, and then let the film stand in the fourth wash for at least 10 minutes.

Once washed, you can remove the film from the spiral and hang it up to dry, vertically, using the clothes pegs to hold it at the top and also to weight the bottom. The film is rather soft at this stage, so try to avoid handling it too much, but it is quite robust when fully dry. When dry, cut your negatives into strips and get scanning!

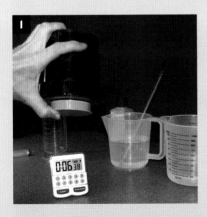

#43 DIGITAL CROSS PROCESSING

Cross processing was popular with certain film photographers for the unique look it gave. The technique basically involves developing film in the wrong type of chemistry, and the most common type of cross processing is to develop print (negative) film using the process designed for positive (slide) film. This produces some fairly odd results, but with a lot of trial and error, the pictures can look really cool, with dramatically increased contrast and wildly oversaturated, inaccurate colors.

The downside to traditional cross processing is that it's both expensive and unpredictable. Depending on the film used, and the development parameters, you're equally likely to get a roll of complete duds as you are to get a roll of killer images. Fortunately, if you shoot digitally it is possible to re-create the classic cross-processed look using your image-editing software.

This project is intended for more advanced photographers, and you will need the full version of Photoshop (or a similar program that features RGB Curves control and Adjustment Layers) so it is possible to take maximum control and produce the most striking images.

DIFFICULTY ★ ★ ★

WHAT YOU NEED

- Image-editing program with RGB Curves control and Adjustment Layers (e.g. Photoshop)

TIP

The settings given are a good starting point, but they are only a starting point—experiment with them to create an individual look.

BELOW Original image

With your image open in Photoshop, go to *Layers>New Adjustment Layer>Curves*. When the Curves adjustment dialogue opens, select *Red* from the channels dropdown list and move the curve into the "S" shape shown here. The image should take on a pinkish tint.

Next, select the green channel, and pull the curve into roughly the same shape as the red curve in step 1. Since most of the data in digital images is contained in the green channel, this adjustment will increase the overall contrast, especially in highlight areas.

The final curves adjustment is to the blue channel, and with this adjustment we want to remove blue from the highlights and add it to shadow areas. Pull the top right point down a little, and the bottom left point up, as shown here. Then pull the curve into a gentle "reverse S" shape. This will give the image an overall yellow cast, but add a lovely rich blue to the shadows.

This step is optional, but if you find that your curves adjustments have increased the contrast and tonal balance of your image too far, change the curves adjustment layer's Blending Mode to *Color*. Don't worry if your image suddenly looks a little flat and unnatural after changing the blending mode—we will correct this in the next step.

#43

New Layer

Name: Color Fill 1 OK

☐ Use Previous Layer to Create Clipping Mask Cancel

Color: ☐ Blue

Mode: Color Opacity: 10 ▸ %

5 The image is almost finished, but I want to add slightly more blue, especially to the shadows and midtones. To do this, choose *Layer>New Fill Layer>Solid Color*, select your color, and then set the opacity—I chose blue as my color, and reduced the opacity to 10%.

When you click *OK*, a color selector appears, and from here you can choose the precise tone that you want to add. Once this is done, change the layer's Blending Mode to *Color*. To finish this image off, I applied a slight vignette using the Lens Correction option from the Filter menu.

TIP

As in traditional, film-based cross processing, fashion and portrait images work well for this technique, but don't be afraid to experiment with other subjects.

ABOVE Final image

#44 DIGITAL INFRARED

Infrared (IR) photography is a classic technique that lets photographers take pictures that are way beyond human vision. This is because infrared wavelengths of light are invisible to the naked eye, and most digital cameras can't see them either.

However, what was once a very specialist, expensive, and unpredictable area of photography has become much easier thanks to image-editing software. Many programs now offer a simple "convert to infrared" option, but while they're great starting points, just pushing a button isn't enough—you need to make a few changes to get the best results.

There are several things that typify an infrared photograph, and if you want to produce the best IR pictures you need to know what to look for. Typically, foliage transmits and reflects high amounts of infrared light, so elements like grass and trees take on a light, often white appearance. At the same time, blue skies don't contain a lot of infrared, so they tend to come out almost black. This can look really dramatic when the sky is punctured by brilliant white clouds. Editing programs are quite good at re-creating the tones, but fall down when it comes to re-creating the unique look of the film itself, which produces "glowing" highlights and obvious grain. So let's look at how it's done properly.

WHAT YOU NEED

- Image-editing software with black-and-white infrared feature

TIP

Because infrared light has the greatest impact on blue skies and foliage, landscape images are a classic for the infrared treatment. However, don't let this stop you trying out other subjects as well.

BELOW Landscape photographs with clear blue skies and green foliage make great infrared pictures, as the skies turn near-black and the foliage glows white.

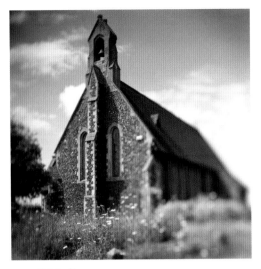

ABOVE Original image

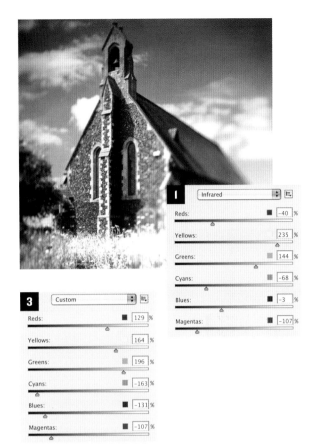

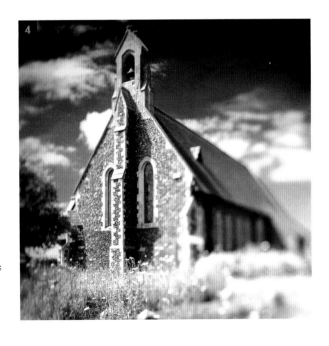

Start by creating a Black & White adjustment layer, either by clicking on the *Create Adjustment Layer* icon at the bottom of the Layers palette or choosing *Layer>New Adjustment Layer>Black & White* from the main menu.

Select the default Infrared option from the Preset dropdown as your starting point. The result hints at infrared, but the sky is way too light, and the highlights at the bottom of the image have been blown out.

You need to make some radical changes to the basic IR settings to create a more convincing result. Starting from the top of the dialogue, the Reds are set to 129% (not -40%) to create the infrared "glow," the Yellows are decreased to 164%, and Greens increased to 196% to lighten the grass, while trying not to let the grass bleach out too much. At the bottom end of the dialogue window the Cyans and Blues are both heavily reduced to darken the sky.

Already the image looks more infrared than Photoshop's default setting, with glowing grass that isn't as burned out, and a dark, brooding sky that typifies IR photography. However, it's still missing the "glowing highlights" and grain that typify infrared film.

#44

5 To add the glow, duplicate the Background layer (*Layer>Duplicate Layer*) and set the duplicate layer's Blending Mode to Lighten. Open the Gaussian Blur filter (*Filter>Blur>Gaussian Blur*) and apply a small blur radius. With this image a radius of 1.3 pixels was all that was needed to add a subtle glow to the highlights.

6 Now you can combine the Background and Background Copy layers. You just want to combine the two color layers, not the Black & White adjustment layer, so turn the Black & White layer's visibility off by clicking the eye icon in the Layers palette. Then choose *Layers>Merge Visible* to blend the two background layers.

7 Use the eye icon to make the Black & White layer visible again, but make sure the color Background layer is highlighted in the Layers palette. To add grain we'll start with some noise (*Filter>Noise>Add Noise*). The amount you add entirely depends on taste. I like my grain to be noticeable, so for this image the Amount was set to 7%, the Distribution to Gaussian, and I made sure the Monochromatic box was checked.

8 To transform the noise into "grain," soften it slightly using the Gaussian Blur filter. You only need a very small amount of blur—the aim is to take the edge off the "hard" noise, not to overly soften the picture. A 0.4 pixel radius was all that was used here.

9 Because adding noise tends to reduce the apparent contrast of a picture, boost the blacks and whites with a quick Levels tweak (*Image>Adjustments>Levels*). Setting the black point (left slider) to 5 and the white point (right slider) to 250 bumps up the contrast a touch. If this clips the highlights or shadows it isn't a problem—it adds to the contrasty, infrared look of your finished image.

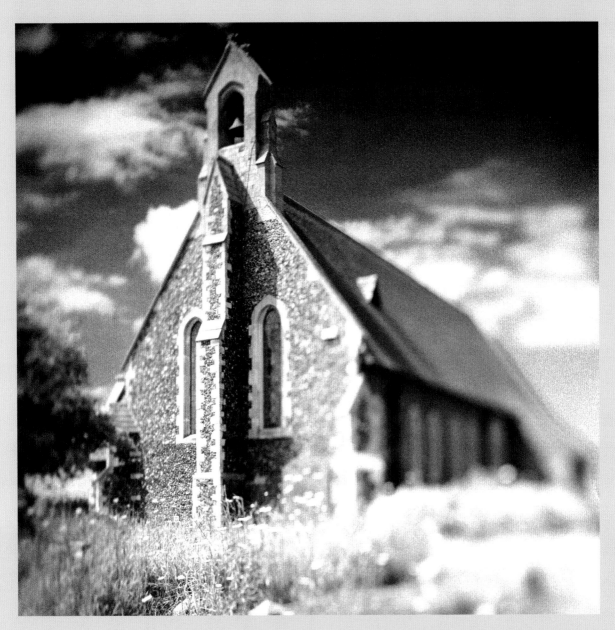

ABOVE Final image

#45 SUN PRINTS

One of the oldest photographic printing processes is the cyanotype, which originally used potassium ferricyanide and ferric ammonium citrate to create a mildly photosensitive solution that was coated onto paper to make it sensitive to light. Although the process was devised by Sir John Herschel in the early 1840s, it was a friend of his—Anna Atkins—who first adopted it as a means of creating photographic images. Her book, *Photographs of British Algae: Cyanotype Impressions*, was not only the first book to show the potential of the cyanotype process, but it was also the first book to be illustrated with photographic images, beating William Henry Fox Talbot's *The Pencil of Nature* by just eight months.

The cyanotype process is still used today, and as an entree into the world of traditional printing it has plenty going for it: there's minimal chemistry needed; the sensitized paper can be handled in subdued daylight; exposures require nothing more than daylight; and the exposed print is developed in plain water. However, the process can be made easier still thanks to precoated "sun print" paper, which you can buy from craft stores or online. So, if you've ever wanted to experiment with an old-school process, but didn't know where to start, or wanted to produce the distinct blue prints of a cyanotype, but didn't want to mess with chemicals, this is the project for you.

DIFFICULTY ★ ★

WHAT YOU NEED

For photograms:
- Sun print paper
- Bowl or tray of water
- Sheet of corrugated card

For digital negative printing:
- Sun print paper
- Bowl or tray of water
- Image-editing program
- Inkjet (or laser) printer
- Acetate for printer
- Clip frame

TIPS

Sun print paper relies on UV light, rather than actual sunlight, so you can make exposures on a cloudy day, or even indoors. However, for the best results a strong UV light source delivers the best results.

As an alternative to the sun, you can also use a UV sun lamp (the type designed for facial tanning is ideal). As many of these have a timer, you can fine tune your exposures so they can be repeated over and over, in much the same way as using an enlarger on regular photographic printing papers.

GETTING STARTED

The simplest starting point for your sun print experiments is to create photograms, in much the same way as Atkins did in the mid 1800s. If you've done a beginner's course in traditional black-and-white printing then you'll probably know what photograms are (it's a fairly standard start point), but if not, it's pretty straightforward: you place items on the paper and then expose it to light. The result is a reversed image, so the areas your objects cover will receive little or no exposure and appear light when the paper is developed, while areas that aren't covered will come out dark (blue) when you process the paper.

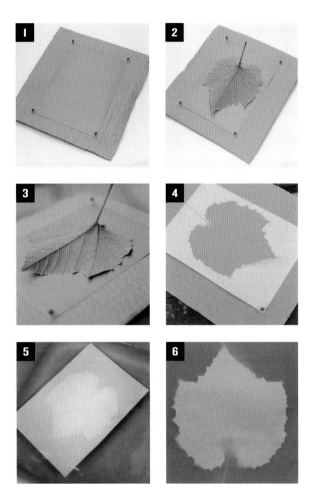

1 Indoors, or in shade, take a sheet of sun print paper from the packet and pin or tape the corners to a piece of card.

2 Assemble your objects on top of the paper. Remember that the areas they cover will be unexposed, and appear light in the final image, while uncovered areas will appear dark. To start with, consider keeping things simple by sticking to strong, identifiable shapes, such as keys, leaves, or anything else with a strong outline.

3 Carefully take your paper and objects out into the sun. Place them in direct sunlight to make your exposure: the paper I'm using here recommends an exposure time of around two minutes, "until the paper turns very pale blue."

4 Once you've made your exposure, remove your object(s) and unpin/untape your sun print paper. You'll notice a ghost image at this stage.

5 Take your paper indoors (or back into a shaded area) and place it in a tray of water for around 60 seconds. You can agitate the tray slightly during this time if you want to. As the water washes the print, the unexposed areas will lighten, while the rest of the paper will darken.

6 After you've washed your print, remove it from the water and leave it to dry: either flat on an old newspaper, or hanging up on a washing line or similar. As the sun print paper dries, the color will intensify and the image will appear to get sharper.

#45

DIGITAL NEGATIVES

Once you've mastered photograms (which, let's face it, won't take long), you'll probably be wanting to produce slightly more "photographic" images. This requires you to produce negatives at the final print size, as there's no scope to make enlargements from a negative. In the past, this would have meant using a large-format camera to make equally large prints, but thanks to digital imaging this is no longer the case: you simply need a desktop printer and some sheets of compatible acetate or clear film to print on.

1 Open your image on your computer and turn it into black and white (all image-editing programs have a "desaturate" or "black and white" option).

2 Next, you need to invert your black-and-white image so that it appears on screen as a negative: blacks become white, and whites become black. This is because the sun print process will reverse the image, so if you start with a negative you will end up with a positive print.

3 Sun print paper delivers low-contrast results—black is replaced by dark blue, and white by light blue—so it's a good idea to boost the contrast of your negative image. Again, all image-editing programs will provide you with contrast control, be it through "levels," "curves," or simply a generic "contrast" tool.

4 The next step is to resize your image so that it matches your intended print size. For example, if you want to make a 6 × 6-inch (15 × 15cm) print, you will need to size the image accordingly.

5 Print out your negative image onto acetate, or a similar printable clear film. Place a sheet of sun print paper on the backing board of a clip frame and lay the negative on top. Make sure the glass from the frame is free of dust and smears and clip the frame together.

6 You can now make your exposure, which is done in the exact same way as it is for a photogram: take your frame outside; expose it to sunlight; and then head back indoors to wash/develop the image before leaving it out to dry.

RIGHT & ABOVE I like to use natural objects, mimicking early cyanotypes; here I've used a sheep's skull (above) and a leaf (right).

#46 DIGITAL DAGUERREOTYPE

Photography as we have come to know it was arguably born when Frenchman, Louis Daguerre announced his daguerrotype process in 1839. However, as with most inventions (photographic or otherwise), this pioneering technique wasn't the easiest, or indeed the healthiest.

The "printed on metal" image could not be replicated easily and possessed an exceptionally delicate surface that was easily damaged through handling or chemical contamination. This is part of the reason why original daguerreotypes are relatively rare, and few of those that remain are in a perfect state.

With this project, we're going to use Photoshop to recreate the look of a weathered and aged daguerreotype, which requires two main elements: a photograph of a suitably vintage subject and an aged, metal texture to "print" it onto.

ABOVE & RIGHT Original images. I'm starting with a photograph of a pier that opened in 1870 (above) and a stock metal texture with a distinct patina (right).

Daguerreotypes are invariably black and white, so the first step is to take the color out of your subject (but not the metal texture). You don't need a fancy black-and-white conversion for this, but you do want to make sure that the image remains in the RGB color space. Using the desaturate command (*Image>Adjustments>Desaturate*) gives a suitable flat grayscale conversion.

2 Next, open your texture and copy and paste it (*Edit>Copy, then Edit>Paste*) onto your main image. It will automatically be placed on a separate layer, but you will need to resize it (using *Edit>Transform>Scale*) so that it matches the size of the image.

3 To allow your image to appear through the texture, change the texture's blending mode from Normal to Multiply, and reduce the layer opacity. Here, I've set the Opacity to 35%, which gives a good balance between the image and the texture.

4 To fine-tune the layers, add a Curves adjustment layer (*Layer> New Adjustment Layer>Curves*). Generally, you will be looking to reduce the contrast of the image by lowering the top right of the curve (the highlights) and raising the lower left (the shadows).

#46

5 For added authenticity I'm going to add a vignette and slight focus fall-off at the edges of the frame to emulate the look of an old lens. Select the Elliptical Marquee tool and, while holding down the Alt key, click and drag out from the middle of the image to create a centered elliptical selection. Invert the selection (*Select> Inverse*) so the outer edges of the image are selected.

6 To make the selection fall off in a subtle fashion, switch to Quick Mask mode (press Q on the keyboard) and apply the Gaussian Blur filter (*Filter>Blur>Gaussian Blur*). I've used a 200-pixel blur radius to soften the mask. Press Q to return to the Standard Editing mode and, making sure the Background layer is selected, copy and paste your edge selection into a new layer (*Edit>Copy/Edit>Paste*).

7 Edges copied to a separate layer can be worked on independently. Here, I've used Levels (*Image> Adjustments>Levels*) to intensify the shadows and slightly lower the midtones, and then applied Gaussian Blur with a 5-pixel radius to soften the focus slightly.

8 You can finish here if you're happy with the way your image looks, but I'm going to round off the corners to add to the vintage feel. To start with, this means increasing the size of the canvas. The actual measurements aren't important—you just need a small border (1 inch/2.5cm is enough).

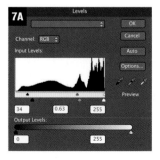

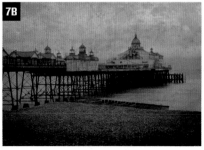

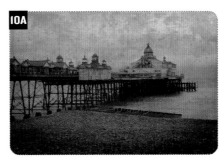

9 Select the image with the Rectangular Marquee tool and smooth the selection (*Select> Modify>Smooth*) by 100 pixels (the maximum amount permissible). Repeat the 100-pixel smoothing to get nicely rounded corners and then Feather the selection (*Select>Modify>Feather*) by 1 pixel to avoid the corners appearing pixelated. Invert the selection (*Select>Inverse*).

10 Create a new layer (*Layer>New*), and fill the edge selection with white (*Edit>Fill*). Drag the border layer to the top of the layers palette so that it affects all of the layers below it and your digital daguerreotype is done!

BELOW Final image

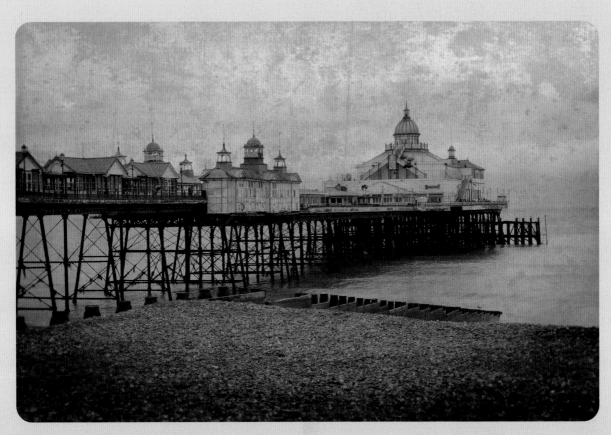

#47 MODEL WORLD

In Project 28 you saw how to make a tilt lens that will let you take some really cool shots with a narrow band of focus. Making your own lens is great, but it's not something you will always carry around with you, and you need to have an SLR camera to start with—it's not much use if you use a digital point-and-shoot camera.

That doesn't mean that you can't play around with selective focus in your pictures though, and this project will show you how you can re-create the effect using your image-editing software. I made my image using Photoshop, but most image-editing programs will have the tools you need; they might just be called something else.

DIFFICULTY ★ ★

WHAT YOU NEED
- Image-editing program with gradient tool and lens blur filter

TIPS

Your focus doesn't have to run horizontally across the picture—a tilt lens will let you change the direction of the zone of focus (also known as the "plane of focus"). So, instead of having a horizontal plane of focus, try creating one that runs diagonally—or even near-vertically—through the picture by making the gradient in steps 3 and 4 go in a different direction.

This technique is especially effective when your starting picture is taken from a high viewpoint. If the scene is quite contrasty, that's even better—both of these things will add to the illusion that the viewer is looking down on a small-scale model that has been lit by a single, close light source.

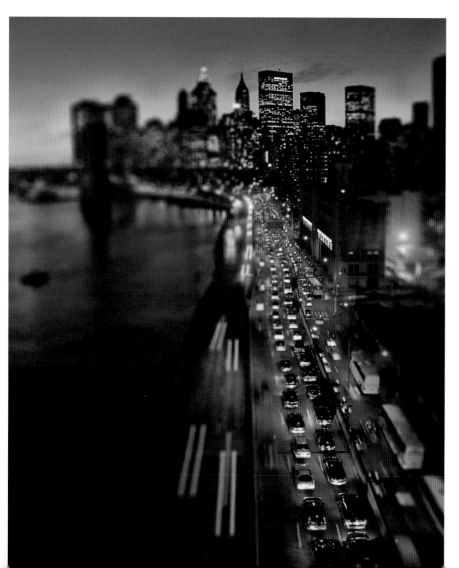

LEFT A busy scene with a wide view, shot from above, works particularly well for the "model world" treatment.

Original image

1 Start by selecting the area you want to keep in focus. In Photoshop, you'll do this using the Quick Mask mode and the Gradient tool. You can toggle between Standard Editing and Quick Mask mode using the toolbar, or by pressing *Q* on the keyboard.

2 In Quick Mask mode, select the Gradient tool from the toolbar. Choose *Reflected Gradient* from the tool options at the top of the screen, then press *D* to set the default colors to black (foreground) and white (background).

3 To select the zone of focus, click on the image in the center of the area you want to remain sharp, and drag the cursor upward. If you hold down the Shift key while you do this it will lock the selection so it's perfectly straight.

4 When you release the mouse, the gradient will be shown as a semi-opaque red mask (the default Quick Mask color). The red mask shows the area you've selected that will remain in focus. Return to the Standard Editing mode (Q) and the familiar "marching ants" will outline the unselected area that you will blur.

#47

5 To create the focus fall-off, use Photoshop's Lens Blur filter (*Filter>Blur>Lens Blur*). The Lens Blur filter has quite a few settings to play with (and feel free to experiment with them), but I'm only changing two of them here—the Iris and the Radius, which I've set to Octagon and 56 respectively. Click *OK* when you are done.

6 It takes a while for the filter to be applied—maybe a minute or more depending on the size of your image and the speed of your computer. Once the filter has been applied, the focus effect is fairly obvious. You could finish at this point if you wanted to, but there are a few more things I want to do with this image.

7 I want to give this image more of a "model" feel, so it looks slightly more like a constructed, small-scale set. To enhance the "plastic" appearance of the picture I'm going to adjust the saturation and the contrast. Call up the Hue/Saturation dialogue (*Image>Adjustments>Hue/Saturation*) and slide the saturation slider to the right to increase the color—10–25 is normally enough.

8 Finally, I'm going to use Curves (*Image>Adjustments>Curves*) to bump up the contrast. This will also make the color "pop" a little more. Add a point toward the top right of the curve and drag it slightly upward to lighten the highlights. Add another point at the opposite end of the curve and lower the bottom left to darken the shadows. And that's it—a straight city scene has been transformed into a small-scale model town.

RIGHT Final image

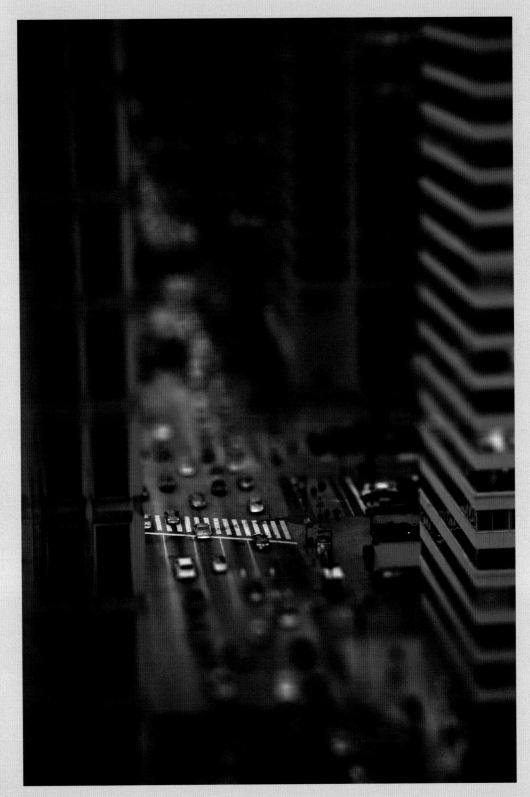

#48 DIGITAL REDSCALE

It is possible to roll your own redscale film and start shooting images with a limited color palette, but shooting film isn't the cheapest option (even if you roll your own redscale), and the results are not predictable either. Although this unpredictability is actually part of the fun of shooting film, it's not for everyone, but just because you choose not to use film doesn't mean you can't get the redscale look with your digital images: there's every chance that your image-editing program can help you out. For this project I'm going to be using that Adobe stalwart—Photoshop.

DIFFICULTY ★

WHAT YOU NEED
- Image-editing program with Curves, Hue/Saturation (optional)

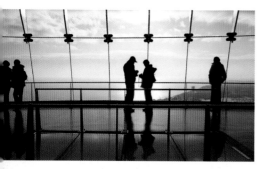

1 Curves is a great way of changing the color in an image, and it's the basis for this project. So, the first step is to create a Curves adjustment layer (*Layer>New Adjustment Layer>Curves*).

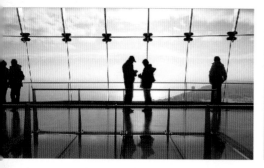

2 Use the dropdown menu at the top of the Adjustments palette to switch from the "master" RGB curve to the Red channel. Raise the left end of the curve directly upward to about the mid-way point, and then add an anchor point approximately halfway along the curve. Drag this point upward to introduce an overall red color cast.

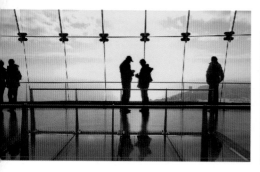

3 Switch from the Red channel to the Blue channel using the drop-down menu in the Adjustment palette. Click on the upper right end of the curve and drag this point straight down, to around the halfway point, to pump up the yellows in your shot.

4 Use the dropdown menu to revert back to the "master" RGB curve (represented by a black line). This curve controls the overall dynamic of your image and it's up to you how you change it: I've added a single anchor point to the left of the curve and dragged it downward to intensify the image.

5 The redscale look is achieved almost entirely with this single Curves adjustment layer, but you can further fine-tune the color with a Hue/Saturation adjustment layer (*Layer>New Adjustment Layer>Hue/Saturation*). In this example I've reduced the Hue to -5 and the Saturation to -15 to create a slightly subtler result.

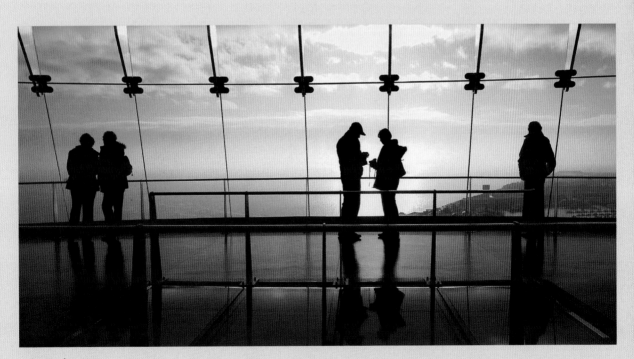

ABOVE Final image

#49 PANORAMAS

There are times when you will find that even the widest zoom setting or focal length on your point-and-shoot camera or digital SLR just isn't wide enough to record the scene in front of you. When this happens, the answer is to create a panoramic image. This is a two-stage process that starts with shooting a sequence of shots to create the panorama—basically taking several pictures to photograph your subject from one end to the other. Back at your computer you can use your image-editing program to merge all of these pictures together and produce a single panoramic photograph.

DIFFICULTY ★ ★

WHAT YOU NEED

- Tripod (to align images when shooting)
- Remote release (optional)
- Image-editing program with "photo merge" feature

SHOOTING

A tripod is a great idea because it will help you align your images as you shoot them. A remote shutter release cable may be useful as well, but it's not absolutely necessary.

Start by finding a suitable scene: something that's nice and wide, with lots of amazing detail to capture—like a distant cityscape, or landscape view. Set your camera up on your tripod, and make sure the tripod is level—if it isn't, your panorama will be sloping when you join your sequence of images together.

Line your camera up at one end of the scene you want to photograph (most photographers start at the left). It's a good idea to set your camera to its Manual shooting mode to take your pictures, and set an aperture of f/8–f/16 for a good depth of field. Next, set an appropriate shutter speed. Because you're in Manual mode each picture in the sequence should receive the same exposure so it will match the one next to it.

Now, take your first shot. Then, turn the camera slightly to the right—so you're looking at the next bit of the scene—and take a second shot. The trick with a panorama is to overlap the images in your sequence slightly so the software can find

TIP

Shoot in portrait (upright) orientation to get a more detailed image, though you will have to take more shots and the result will be a much bigger file. If you use a 10-megapixel camera, for example, you might end up with a panoramic image of around 30 megapixels shooting in landscape format, versus a massive 90-megapixel picture if you shot upright images!

elements that are common to both of the pieces it's joining, and automatically align them for you. An overlap of roughly 1/3 of the frame is enough for most software, although some compacts have a brilliant panoramic shooting mode that shows you the previous image so you can easily align the next one in the sequence.

Continue shooting until you have covered the full width of the scene, from left to right, overlapping your images as you go.

#49

EDITING

Once you've shot a sequence of images you need to combine them into a single panoramic photograph. I'm going to use Photoshop here, but most editing programs will allow you to merge—or "stitch"—images together.

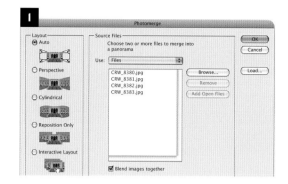

1. Open Photoshop, and choose *File>Automate>Photomerge* from the menu. Use the Browser to find all your images. At the left of the Photomerge dialogue are four Layout options, but I suggest you leave this set to Auto. If you have overlapped your sequence of images correctly, Photoshop can do an excellent job on its own, and will use several of the other tools to achieve the best result. Check the *Blend Images Together* option at the bottom of the dialogue for better blending across the panorama. Then press OK.

2. Once Photomerge has run its course, you will be presented with your panorama, which should have no visible joins. However, the different images will be on different layers, so you will need to flatten the layers (*Layer>Flatten Image*).

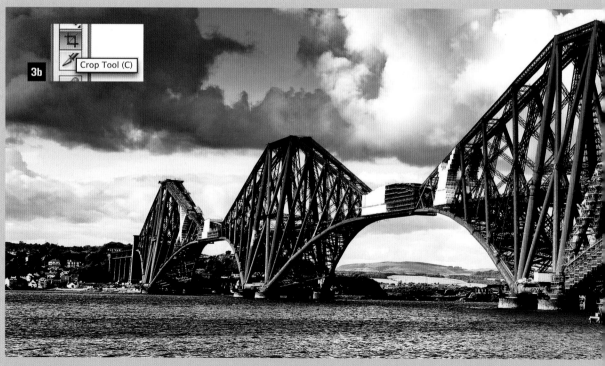

ABOVE Final image

3 You will probably find that parts of the sequence have been cropped in places, resulting in a few gaps at the top and bottom of the photograph. To remove these empty areas, choose the Crop tool from the toolbar and drag a crop box around the good areas so you remove the empty space. Click on the check box or press *Enter* to crop the image.

4 After you have cropped your image you can process it like any other picture—converting it to black and white, increasing the levels to add punch, or whatever else you want to do. For the finished image shown below, I tonemapped the image using Photomatix Pro to create an HDR-style image.

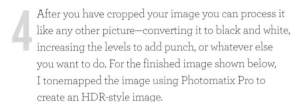

#50 DIGITAL CYANOTYPES

As photography has progressed over the last century and a half there have been hundreds of different processes for making prints, and many of these can be emulated using basic image-editing software. The trick to accurately re-creating an old process is to understand a bit about how that process worked. While this is not essential for creating an original and pleasing picture, it will help you produce something that looks believable and authentic.

The cyanotype process (see also Project 45) was invented in the 1840s as a cheap and easy way of making prints from large format negatives. It used a mixture of potassium ferricyanide and ferric ammonium citrate that was usually coated onto a piece of paper that would be sandwiched with a negative and exposed to UV light (sunlight). After the exposure, it would simply be washed in water, which would wash out the unexposed highlight areas, with the image drying down to a deep blue color.

When it comes to re-creating this effect you should remember that traditionally, the dark areas of the scene would end up the most blue, while lighter areas would be less well-colored, although even the brightest parts of a picture would not be pure white. So a "true" cyanotype should contain subtle tones and be fairly low contrast. As the cyanotype solution would also be coated onto a heavy art paper or watercolor stock, we would expect texture as well—all of which is easy to emulate in your editing software.

DIFFICULTY ★ ★

WHAT YOU NEED
- Image-editing program with layers, blending modes, and curves

TIP
Use a different color than blue to create alternative toned images. They won't look like "proper" cyanotypes, but you can produce some great-looking images.

RIGHT Original image

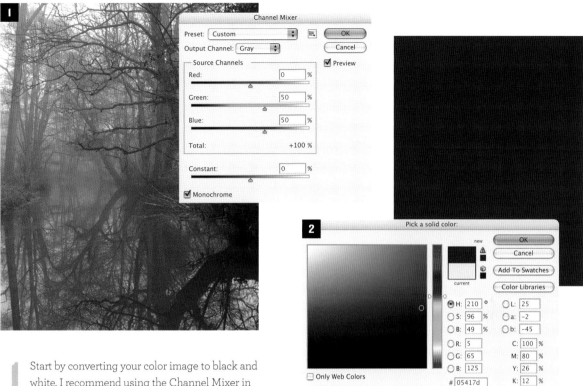

Start by converting your color image to black and white. I recommend using the Channel Mixer in Photoshop and applying settings that give equal weight to the blue and green channels. As traditional glass plates had no sensitivity to red, excluding it will deliver a more authentic feel. If your software doesn't feature a Channel Mixer, don't worry—simply choose the Desaturate option instead.

Next, create a new layer and choose *Layer>New Fill Layer>Solid Color* from the menu. Click *OK* and you will be asked to pick a color in the Color Picker window. As a good starting point, enter values of R: 5, G: 65, and B: 125 into the RGB boxes at the bottom left of the window. Choose *OK* and your picture will disappear behind a solid blue curtain.

To make the picture show through, change the fill layer's Blending Mode to *Overlay* from the dropdown menu at the top of the Layers palette.

#50

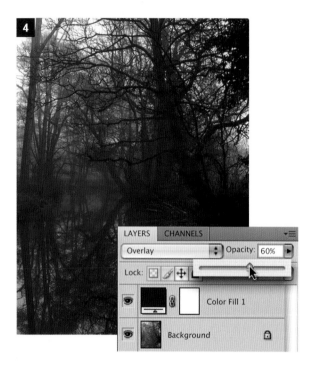

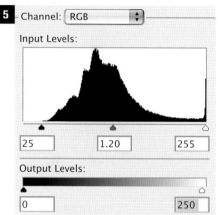

5 Channel: RGB

Input Levels:

25 1.20 255

Output Levels:

0 250

LAYERS CHANNELS

Overlay Opacity: 60%

Lock:

Color Fill 1

Background

6 Texturizer

Texture: Sandstone

Scaling 68 %

Relief 3

Light: Top

☑ Invert

4 You might find the blue is too strong, as the colors take differently to every picture, so reduce the strength of the color using the opacity slider.

5 Some contrast adjustment will probably be necessary now, so click on the Background layer and open the Levels dialogue (*Image>Adjustment>Levels*). Move the black (shadow) Input Levels slider to the right to darken the shadows. Shift the white (highlight) Output Levels slider at the bottom of the dialogue window to the left to slightly darken the highlights and add a subtle tone to them.

6 Finally, Photoshop's Texturizer filter (*Filters>Texture>Texturizer*) is great for adding a subtle paperlike texture to the image—the Sandstone texture looks best. Keep the Relief set to a value of 2–5, but experiment with the Scaling and Light settings as the effect of these will depend on the image size.

TIP

Instead of using Photoshop's Texturizer filter to add the appearance of textured paper, try printing on heavy art paper for a more realistic look.

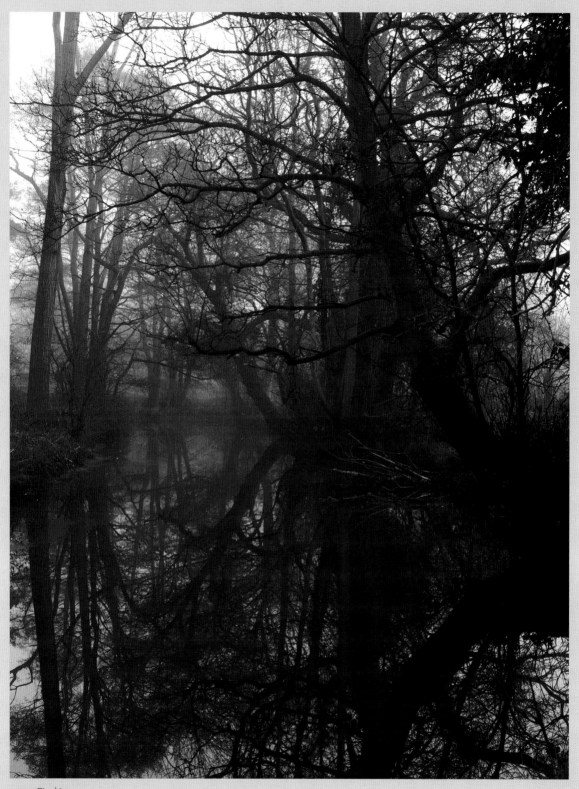

ABOVE Final image

#51 INKJET TRANSFERS

Almost everyone has an inkjet printer hooked up to their computer at home, and most printers will give you fantastic photo prints that are packed with detail. If you're printing out your vacation or family photos this is all you could ask for, but if you want to get more creative, why not use your printer as the starting point for a great project—inkjet transfers.

Making inkjet transfers requires a couple of steps beyond just pressing the print button, but it isn't difficult and can transform your pictures into truly unique works of art, as no two transfers are ever the same. What we're going to do here is transfer the image produced by your inkjet printer onto another surface, such as watercolor paper, heavy cardstock, wood—in fact almost anything you want to experiment with. The results are just as varied, and can range from bold, stencil-like street art images to delicate pictures that take on the soft feel of a watercolor painting. It all depends on the original image you use.

DIFFICULTY

WHAT YOU NEED

- Inkjet printer
- Shiny backing paper from adhesive labels
- Watercolor paper or similar to transfer the image onto
- Rubber roller (optional)

TIPS

Instead of using the shiny backing paper, you can use transparency film (acetate) instead. Make sure the film you use is NOT designed for inkjet printers because inkjet film is designed to absorb the ink, which you don't want it to do.

Experiment with different receiving surfaces—some respond better to inkjet transfers than others. In general, naturally absorbent surfaces work best as they allow the transferred ink to soak into them.

Your transfered image will appear reversed, so what is on the left of your computer screen will be on the right of your transfer. If you don't want this, flip the image horizontally before printing it.

LEFT A high-contrast, textured treatment turns a simple shot of toy cowboys into an atmospheric standoff.

THE TRANSFER PROCESS

The starting point is to print onto a non-absorbent surface such as the shiny backing paper you get with adhesive labels (the sheet that's left when all the labels have been removed).

1. Open up the image you want to transfer on your computer, load your printer with a sheet of your shiny backing paper, and open your printer settings by clicking *Print*. You want to get plenty of ink onto the paper for the transfer, so set your Media or Paper Type to Glossy Photo Paper to do exactly that. Then print your image onto the *shiny* side of the backing paper.

 Now comes the crucial bit. Take your print out of the printer, being very careful not to smudge the wet image—it won't dry like a regular print. Position the print ink-side down onto your "receiving surface" (your watercolor paper, cardstock, wood, or whatever), making sure you don't move either the print or the surface underneath.

2. To transfer the image, apply pressure across the back of the print using the side of your hand or a rubber roller. This will transfer the ink from the backing paper into your receiving surface. Again, don't let the backing paper or the surface underneath move around or it will smear the image, although this can add to the effect.

3. Finally, peel off the backing paper and your image will have been magically transferred to your receiving media!

ABOVE AND LEFT Images can be transfered onto a range of surfaces, from a variety of papers and cardstocks (*above*) to wood (*left*). The clarity of the image will depend on the surface you are using.

#52 DRAGAN EFFECT

Advertising photographers are perhaps some of the most creative practitioners working in photography. I don't mean that to belittle anyone else, but the very nature of their chosen genre means that an advertising photographer has to be constantly looking at new ways of approaching their subject, in an attempt to produce fresh images that stand out in an über-competitive marketplace.

Polish photographer Andrzej Dragan is a prime example of this, and it is the broad look of what has become known as the "Dragan effect" that forms the basis of this project. Combining deep blacks with sharp detail, the end result is almost HDR-like in its appearance, and is also reminiscent of the effect used by Zack Snyder in his 2006 movie 300. If you're unfamiliar with this look, head over to Andrzej's website at www.andrzejdragan.com—you won't be disappointed.

BELOW Original image

WHAT YOU NEED

- Photoshop (Raw files only)
- Adobe Lightroom (Raw or JPEG)
- Digital image

NOTE

For this project you can use either Adobe Photoshop or Adobe Lightroom if you're processing a Raw file, but only Lightroom is suitable if you are processing a JPEG. Why? Because Lightroom has one key tool that Photoshop does not—Clarity. While Clarity is available in Photoshop's Camera Raw module, it does not feature in the program itself. So, for this project—and the JPEG file I'm working with—it had to be Lightroom.

With the image open in Lightroom, activate the Develop module and the Basic tools. Start by bumping up the Clarity to around +50, and then boost the Vibrance to its maximum setting (+100). These two adjustments will really make your image "pop."

To prevent things looking too unnatural, reduce the Saturation. Setting it to around -50 will usually help to tone things down, although the color is "cleaner" compared to the original shot.

A key part of the Dragan effect is deep, impenetrable blacks, so crank the Blacks slider up to the +50 mark—the image appears to be getting worse, not better, but stick with it.

#52

4 The Fill Light slider is the next one to be tackled, and it simply needs to be increased to lift some of the density that we just added, but without destroying the rich blacks entirely. Somewhere in the range +75–90 is usually sufficient to do the job.

5 The basic effect is now in place, and consists of heightened color, increased sharpness, and deep blacks that still enable us to distinguish detail. All of this is achieved using just the five sliders outlined above, and you can now fine tune the result in any way you see fit. Here, I'm going to take things a step further though, starting by applying a Medium Contrast curve from the Tone Curve dialog.

6 My second optional step is to apply a vignette, which is done via the Vignettes dialog. The aim is to shade the corners a little more to help hold the viewer's gaze on the subject in the center of the shot. With that, the picture is complete.

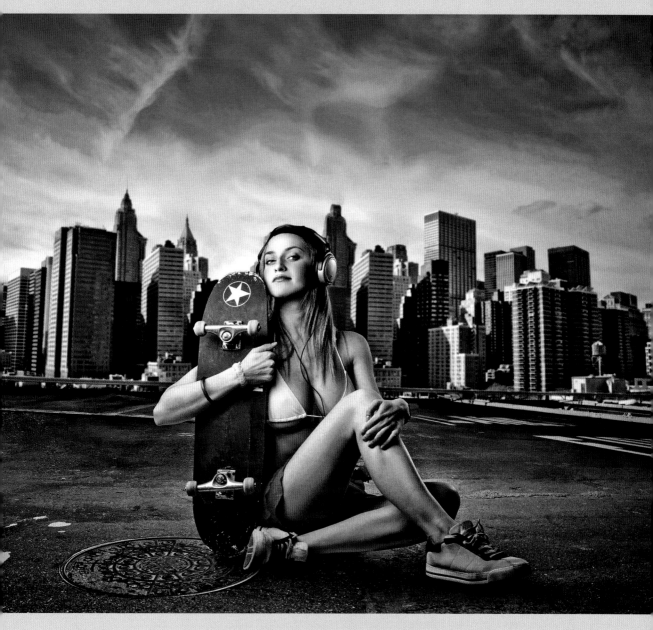

INDEX

PICTURE CREDITS

All images are by Chris Gatcum at www.
cgphoto.co.uk unless listed below. The
publishers would like to thank and
acknowledge additional photographers
as follows.

2 Joshua Fuller/Unsplash; 4 Nikola Johnny
Mirkovic/Unsplash; 8 Stockbyte/Photos.
com, www.photos.com; 12 Sgt. Mark Fayloga,
United States Marine Corps; 13 left Stockbyte/
Photos.com, www.photos.com; 15 above Peter
Adams/iStockphoto.com, www.padamsphoto.
co.uk; 15 below Timothy J. Vogel, www.flickr.
com/photos/vogelium; 16, 17 above Damien
Demolder, www.damiendemolder.com; 17
below Amanda Rohde/iStockphoto.com, www.
designtangents.com.au; 19 Brendon Burton,
www.flickr.com/burtoo; 20-21 David Taylor,
www.davidtaylorphotography.co.uk; 22 left
Lily Banse /Unsplash; 22 right Steven Ramon/
Unsplash; 23 above Parker Johnson/Unsplash;
24 left Steve Corey, www.flickr.com/photos/
stevecorey; 24 right Alex Smith/Unsplash;
25 Robert Zunikoff/Unsplash; 26-28 text and
images Daniel Lih, www.flickr.com/photos/
daniellih; 31 below right Lior Filshteiner/ www.
istockphoto.com; 34 Hao Wang/Unsplash;
35 Bruno Thethe/Unsplash; 36 left Frank
Busch/Unsplash; 36 right Fred Kearney/
Unsplash; 37 Molly Statt/Unsplash; 38 Sumit
Saharkar/Unsplash; 39 above, 40 Konradlew/
iStockphoto.com; 41 Evgeni Savchenko/
Unsplash; 42-45 text and images Rosie
Kernohan, www.rosiekernohanphotography.
com, www.flickr.com/outoftheros; 46-49 text
and images Luis Argerich, www.luisargerich.
com; 50 Ricardo Rocha/Unsplash; 51 Luke
White/Unsplash; 52 Samuele Errico/Unsplash;
53 Ben Parry, www.flickr.com/photos/dialedout
54 Patrick Schmidt, www.flickr.com/photos/p_
tumbleweed; 55 above right Michael Barnes,
www.toycamera.com; 57, 59 Venus Campos,
www.flickr.com/photos/appleheartz;
60 ooyoo/iStockphoto.com; 61 Gerad Coles,
www.flickr.com/photos/gcoles; 64, 65 below
left Damien Demolder, www.damiendemolder.
com; 66-67 text and images Freddie Peirce,
www.neverstop-photography.co.uk, www.
flickr.com/fineshade; 68 Elena Erda, www.
flickr.com/photos/elenaerda 70, 73, 78-79
Damien Demolder, www.damiendemolder.
com; 82 Michael Barnes, www.toycamera.com;
86 Sabrina Dei Nobili/iStockphoto.com; 89
Linda & Colin McKie/iStockphoto.com, www.
travelling-light.net; 92 Joseph Jean Rolland
Dubé/iStockphoto.com; 96, 100 Richard Sibley,
www.richardsibleyphotography.co.uk; 103
Kateryna Govorushchenko/iStockphoto.com,
www.iconogenic.com; 106 text and images
Jack Watney, www.jackwatney.co.uk; 108, 109
above, 111 above Nick Wheeler www.flickr.com/
photos/nickwheeleroz; 114 Tracy Hebden/
iStockphoto.com, www.quaysidegraphics.
co.uk; 115 above Thomas Stange/iStockphoto.
com, www.tstange.de/foto; 116, 117 below,
118 below left, 119 Nick Wheeler, www.
flickr.com/photos/nickwheeleroz; 120-124
text and concept by Alex Fagundes,www.
flickr.com/mytheoryofeverything, images
by Chris Gatcum; 126 Richard Sibley, www.
richardsibleyphotography.co.uk; 128 Benjamin
Goode/iStockphoto.com, www.kwestdigital.
com.au; 132-135 text and images Richard Kaye,
www.rwkaye.co.uk; 136-139 Barney Britton,
www.barneybritton.com; 152 John W. DeFeo/
iStockphoto.com, www.johnwdefeo.com; 153
Terry Wilson/iStockphoto.com, www.terryfic.
com; 158-161 Pete Carr www.petecarr.net; 162-
165 Damien Demolder, www.damiendemolder.
com; 168-171 Michele Piacquadio/Photos.com,
www.photos.com.

While every effort has been made to credit the
right copyright holders, the publisher would
like to apologise for any errors or omissions
and would be pleased to make corrections in
any future reprint if notified in writing.